Caravaggio's "St. John" *&* Masterpieces from the Capitoline Museum in Rome

Caravaggio's "St. John" & Masterpieces from the Capitoline Museum in Rome

Maria Elisa Tittoni

Patrizia Masini

Sergio Guarino

Wadsworth Atheneum, Hartford, Connecticut
Art Gallery of Ontario, Toronto, Canada

Travelers Insurance and the Citigroup Foundation are the corporate sponsor of *Caravaggio's "St. John" & Masterpieces from the Capitoline Museum in Rome.*

The Travelers is honored to bring this important exhibition to Hartford, the only venue in the United States. For 135 years, Travelers has provided insurance protection (annuities, auto, commercial, homeowners, life and long term care) to our customers across America. Through our partnership with the Wadsworth Atheneum, we look forward to bringing a piece of world history to Hartford for everyone to enjoy.

Keith F. Anderson
Chief Communications Officer

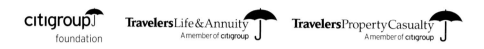

Designed and produced by the Publications Department of the Wadsworth Atheneum

Designed by Ann McCrea

Typeset in Adobe Garamond and ITC Sabon

Color separations by Herlin Press, Inc.
West Haven, Connecticut

Printed by Chatham Printing Company, Inc.
Newington, Connecticut

Copyright © 1999 Wadsworth Atheneum

Library of Congress
Catalog Card Number: 99-71081

ISBN 0-918333-13-X

This catalogue accompanies the exhibition *Caravaggio's "St. John" & Masterpieces from the Capitoline Museum in Rome,* organized by the Wadsworth Atheneum, Hartford, Connecticut.

Wadsworth Atheneum, Hartford, Connecticut
April 20 to June 20, 1999

Art Gallery of Ontario, Toronto, Canada
July 15 to September 12, 1999

Support for this catalogue has been provided by the David T. Langrock Foundation.

Cover: Michelangelo Merisi da Caravaggio, *St. John the Baptist* or *Isaac,* c. 1600

Sponsor's Foreword

The name of this exhibition *The Old Masters: Great Renaissance and Baroque Paintings from the Capitoline Museum, Rome* says it all. This exhibition provides visitors to the Art Gallery of Ontario with a rare opportunity to see a small collection of true masterpieces from the justly famous Capitoline Museum collection. This exhibition is sure to delight all viewers.

Wildeboer Rand Thomson Apps & Dellelce is grateful for the opportunity to play a part in bringing this extraordinary exhibition to the Art Gallery of Ontario. Our law firm was founded in January 1993 with the objective of providing exceptional service to clients in securities, corporate and tax matters. We represent a wide range of public and private companies, as well as investment dealers, lenders and private investors.

We congratulate the Art Gallery of Ontario for bringing this exhibition to Toronto, and we are proud to have participated in its success.

WILDEBOER RAND THOMSON APPS & DELLELCE
Barristers & Solicitors

Contents

Preface

Commentaries

The dimensions of the works in the Commentaries
are given in centimeters as well as in inches,
height before width.

Directors' Forward

It is an honor to be able to present this select exhibition of twenty-one Renaissance and Baroque masterpieces from the Capitoline Museum in Rome, the first international traveling show from the world's oldest public museum. In Hartford we are especially pleased, since the Wadsworth Atheneum is renowned not only for its Italian Baroque paintings, but also as the first American museum to mount a show on this topic (1930) and the first to acquire a Caravaggio (*The Ecstasy of St. Francis* in 1943). Furthermore, one of the highlights of our collections is Giovanni Paolo Panini's large "portrait' of the picture gallery of Cardinal Silvio Valenti Gonzaga (1690-1756), a pictorial inventory of the personal collection of the founder of the Capitoline Museum. It depicts the cardinal and his many paintings in a grand imaginary hall (page 44). In some respects, this show can also be viewed as a splendid sequel to last summer's resoundingly successful exhibition at the Atheneum, *Caravaggio and His Italian Followers*, which came to us from the Galleria Nazionale d'Arte Antica in Rome. The present exhibition benefits from our continuing special relationship with the museums of the Eternal City. To our colleagues at the Capitoline and in the offices of the Sovraintendenza Beni Culturali, Claudio Strinati, Maria Elisa Tittoni, Patrizia Masini, and Sergio Guarino, we extend our thanks and admiration.

The exhibition in Hartford is generously sponsored by Travelers Insurance and the Citigroup Foundation, one of the Atheneum's closest and best corporate neighbors. Support for the exhibition catalogue has also been provided by the David T. Langrock Foundation. The Atheneum's preferred airline, Delta Air Lines, has provided special assistance with shipping and couriers. Additional support comes from the Greater Hartford Arts Council and the Connecticut Commission on the Arts, and individual supporters, including Anthony Autorino of the exhibition's Committee of Honor, Thomas Wysmuller, J. William Middendorf II, Richard and Barbara Booth, Dr. and Mrs. Herman Bosboom, Dr. Andrew Hendricks, Julien Redele, Cornelius J. Vangemert, and Mrs. Alexander O. Vietor.

We also gratefully acknowledge the support of the officials and representatives of the Italian Government including: His Excellency Ferdinando Salleo, Italian Ambassador to the United States; Giorgio Radicati, Consul General of Italy; Adolfo Barattolo, Vice Consul General of Italy; Giuseppe Perrone, Cultural Attaché of the Embassy of Italy. For their invaluable support, special thanks are due to Eric Zafran, Curator of European Painting and Sculpture, and Cindy Roman, Associate Curator of European Art, as well as the following staff members: Cecil Adams, Susan Hood, Polly Kallen, Betsy Kornhauser, Stephen Kornhauser, Charlie Owens, Dina Plapler, Matthew Siegal, and Nicole Wholean. The catalogue has greatly benefitted from the assistance of Jean Cadogan, Professor of Fine Arts, Trinity College, who provided valuable aid in the translation and editing of the manuscript; the design of Ann McCrea, Graphic Designer, Wadsworth Atheneum; and the copy editing and production assistance of Don Wentworth, Publications Editor.

It is a privilege to be able to share this show with our Canadian colleagues at the Art Gallery of Ontario in Toronto, a sister institution with a long and distinguished exhibition history.

Peter C. Sutton
Director
Wadsworth Atheneum, Hartford

It is a pleasure to share with the Wadsworth Atheneum this remarkable exhibition of masterpieces of Baroque painting. To bring these works before a Canadian public, and thus provide access to a profound and transformative moment in the history of art, is a rare privilege. We thank Dr. Peter Sutton and his colleagues at the Wadsworth Atheneum for inviting us to be partners in this presentation, and acknowledge with much appreciation the extended hand of our friends at the Capitoline Museum, and our Committee of Honor, Consul General of Italy Francesco Scarlata, and Dr. Joseph M. Tanenbaum, C.M.

In less than a year the Art Gallery of Ontario will celebrate its 100th anniversary as a public institution. While we are young by international standards, we have occupied an important place in the expanding consciousness of our country. To anticipate this milestone in partnership with the Atheneum, and in recognition of the Capitoline, the oldest public museum in the world, seems very much of the moment for us: we are celebrating our past while anticipating our future with renewed faith and ambition.

Matthew Teitelbaum
Director
Art Gallery of Ontario, Toronto

The Capitoline Picture Gallery

The origins of the Capitoline Museum date to 1471, when Pope Sixtus IV transferred to the Capitol a group of bronzes of great symbolic value that were kept in the Lateran Palace, the residence of the pope as bishop of Rome. The group included the *She-Wolf* who suckled Romulus and Remus, legendary founders of Rome; the so-called *Bali of Samson*, a traditional symbol of Roman domination over the world; the *Spinarius*, or *Thorn-puller*; the *Camillus*; and a fragment of a colossal statue formerly in the Basilica of Constantine: the head of the emperor Constantine.

With this gift to the Roman people, the pope trans-formed the Capitol into the locus of Rome's historical identity. The symbolic role of the Capitol was enriched by acquisitions in the first half of the sixteenth century. While the creation by Pope Julius II (pope 1503-1513) of the collection of antiquities housed in the Belvedere of the Vatican may have prevented the expansion of the Capitoline collections, it also served to underscore the public nature of the latter. The Vatican collection, assembled on aesthetic grounds, reflected the princely tastes of successive popes, whereas the Capitoline collection preserved its symbolic and historical function. Visual confirmation of the Capitol's symbolic role was made in 1538, when the equestrian statue of Marcus Aurelius, a second century A.D. Roman original, was brought from near San Giovanni in Laterano to be the center-piece of a new square designed by Michelangelo (who also designed an ingenious new base for the sculpture). Further gifts were made of the Capitoline *Brutus*, an extraordinary bronze portrait traditionally identified with the mythical founder of the Republic; and the *Fasti Consolari* , memorial marble tablets (with the names of the Roman magistrates) that were discovered in 1546 in the Roman Forum and are fundamental documents for reconstructing the history of ancient Rome.

In 1653, upon completion of the Palazzo Nuovo, the last element of Michelangelo's design, the antiquities were transferred to the new building. Nonetheless, it wasn't until 1734, after the acquisition of the Albani collection, that the Roman public collections were chartered as a museum and open to visitors. Finally, in 1749, as one of the most significant and famous examples of enlightened papal patronage in the eigh-teenth century, the Capitoline Picture Gallery was founded through the joint efforts of Pope Benedict XIV (pope 1740-1758) and Cardinal Valenti Gonzaga (1690-1756). A versatile servant of the church as well as a collector and patron of the arts, Cardinal Valenti Gonzaga defended the ancient monuments of Rome from despoliation for building material and protected the cultural patrimony of the city from exportation to foreign collections. He took advantage of the opportu-nity to acquire for the Capitoline two of the main art collections in Rome, that of the Marquis Sacchetti and of the Princes Pio. The Sacchettis needed to sell an important section of their remarkable picture collection to satisfy creditors. Valenti Gonzaga negotiated the sale of part of the collection, valued at 25,000 scudi, and on January 3rd, 1748, the paintings reached the Capitol. Valenti Gonzaga thereby prevented the dispersal of the Sacchetti collection and secured many masterpieces for the Capitoline, including the youthful works of Pietro da Cortona, and several late, evocative pictures by the great Bolognese artist Guido Reni.

Negotiations for the acquisition of pictures from the collection of Prince Giberto Pio di Savoia went on for several years, concluding in 1750. The prince sought permission to export the collection to Spain, but Benedict XIV's newly activist policy of restricted exportation of works of art resulted in a compromise:

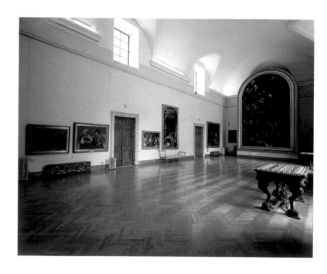

permission was granted on the condition that the prince sell over a fourth of his collection to the city, 126 paintings, for the sum of 16,000 scudi. The selection, made with refinement and intelligence, included many of the best works in the Pio collection: the *Baptism of Christ* by Titian, and *The Fortune Teller* by Caravaggio. The Capitoline museum was expanded, adding the Saint Petronilla Hall for the Sacchetti pictures, and the Hercules Hall for the Pio collection.

In 1818 the great altarpiece of the *Burial of St. Petronilla* by Guercino was brought to the Capitoline, requiring the transfer of works to the Vatican Picture Gallery and to the Accademia di San Luca. These losses were redressed by important acquisitions in the first half of the nineteenth century, including the double portraits by Van Dyck.

The last important acquisition of paintings was a group of fourteenth- and fifteenth-century works on panel, acquired in the 1930s from the Sterbini collection. The already prestigious collection of the Capitoline Gallery was further enriched by other important donations: the Cini bequest of porcelain and eighteenth-century Roman furniture; the Primoli legacy, with eighteenth-century paintings and furniture; and, lastly, the Mereghi gift of Asian porcelains. After the Second World War, several gifts were added to the collection: the exquisite *Holy Family* by Pompeo Batoni (gift of Centurione Scoto); the 1703 *Still Life* by Giovanni Paolo Spadino (gift of Schiff Giorgini); the *Finding of Romulus and Remus* by Andrea Locatelli (gift of Porcella); the *Death of Adonis* by Savonanzi (gift Sir Thomas Barlow); the *Pastoral Scene* of the Master of the Annunciation to the Shepherds (gift of Sussmann Nicod); four tapestries with the *Stories of Semiramis*, mythical queen of Babylon, which were woven in the first half of the sixteenth century in the famous Antwerp tapestry works of Michel Wauters, after cartoons by Abrahm Van Diepenbek (gift of Gasparri Caroselli; this series was completed with the

purchase in the 1990s of the last two episodes). The last and most important acquisition was Pierre Subleyras' noble portrait of Silvio Valenti Gonzaga, to whose energy and prescience the Capitol is indebted for its Picture Gallery.

The Pirelli corporation has generously supported our efforts to enhance the prestige of the oldest public picture gallery in the world by exhibiting this selection of masterpieces on the occasion of the refurbishment of several galleries. For the Renaissance period we have chosen works from the Ferrarese and Venetian schools, which illustrate the vivacity of these important centers; these include the great altarpiece by Dosso Dossi, the *Allegories* by Veronese, and the penetrating portraits by Lorenzo Lotto and Giovanni Girolamo Savoldo. The late sixteenth century is represented by the unusual portrait of the Bolognese painter Bartolomeo Passerotti, one of the first examples of non-official portraiture. *St. John the Baptist* (or *Isaac*) by Caravaggio opens the series of the Roman canvas of seventeenth century: this is not only one of the masterpieces of the Picture Gallery, for the first time (and for exceptional reasons) exhibited outside of Rome, but one of the greatest pictures by Caravaggio from the beginning of his mature period. The lively and cosmopolitan nature of the Roman artistic environment is well represented by other masterpieces by Guido Reni, Domenichino and Simon Vouet; we also are happy to exhibit the recently restored *Saint Matthew and the Angel* by Guercino and the *Self-Portrait* by Velázquez. Two paintings by Gaspar van Wittel document the birth of the modern landscape view, while the *Portrait of Cardinal Silvio Valenti Gonzaga* by Pierre Subleyras is a fitting conclusion to this synoptic, yet fascinating, journey into the oldest public collection of paintings in the world.

Maria Elisa Tittoni
Director, Pinacoteca Capitolina

The Sacchetti and Pio di Savoia Collections

The Capitoline Picture Gallery was created by Pope Benedict XIV and his clever and powerful Secretary of State, the Cardinal Silvio Valenti Gonzaga, through the acquisition in 1748 and in 1750 of two important Roman collections belonging to well-known families, the Sacchetti and the Pio di Savoia. The principal aims of Benedict XIV and Cardinal Valenti Gonzaga were first, to avoid dispersal of hundreds of masterpieces to foreign collections, and, second, to give to the young students of the Academy of St. Luke (the oldest Fine Arts Academy) the opportunity to study the paintings of the past.

The Sacchetti were an ancient and noble family. They had been members of the Florentine aristocracy from the Middle Ages and, in the first years of the fourteenth century, were mentioned by Dante in his *Divine Comedy* (Paradise, XVI, 104). In 1573, Giovanni Battista Sacchetti, at the age of thirty-three, settled in Rome to open a branch of the family bank. In 1579, he married Francesca Altoviti, heir of a rich family of Florentine bankers, who bore him ten children before her death in 1597. Four of the ten children died young. Marcello, the fifth son (born 1586), became the heir of the family fortune after the death of Giovanni Battista in 1620. Marcello was an intimate friend of the Barberini family (fellow Florentines). Soon after the election of Cardinal Maffeo Barberini as Pope Urban VIII in 1623, Marcello was made "General Trustee and Secret Treasurer of the Apostolic Chamber," that is, the banker of the Church. Of Marcello's four living brothers, Giulio (born 1587) was made bishop and, in 1626, cardinal, while Alessandro (born 1589) and Giovanni Francesco (born 1595) entered the diplomatic corps. The only brother who did not receive a special appointment at that time was Matteo (born 1593), yet he would be the only one of the family to have children and to perpetuate the Sacchetti family.

In the early 1620s, the Sacchetti brothers had the family chapel in the church of San Giovanni dei Fiorentini (the "national" church of the Florentines in Rome) decorated with two paintings by Giovanni Lanfranco. This was the first commission in what would become an illustrious patronage career. Marcello, the rich and powerful friend of poets and painters, became one the most famous patrons of Roman painting: his close friendship with Pietro da Cortona is regarded as a model of the relationship between "patrons and painters." The French painter Simon Vouet painted the *Allegory* (cat. 21) for Marcello, and Nicolas Poussin came to Rome from Paris in 1624 bearing a letter of introduction from the Italian poet Giovanni Battista Marino to Marcello Sacchetti, the only one who could help the artist. Marcello preferred to commission paintings directly from artists, rather than purchase pictures from the open market. In August 1626, he was granted a twelve-year right to mine alum in the Tolfa mountains, about 100 kilometers (60 miles) north of Rome, by Urban VIII. Alum was needed to tan skins and the quarry granted very good profits. In the spring of 1629, Marcello was suddenly taken seriously ill; doctors could do nothing (he may have had tuberculosis). During the summer Marcello was taken to Naples, where the climate was better. From Naples, on July 21, 1629, he wrote one of his last letters to the powerful Cardinal Mazarin in Paris; by September 14 he was dead. Before leaving Rome, Marcello had granted power of attorney to his brother Matteo, and for a long time thereafter documents and payments of

the Sacchetti bank were made in Marcello's name, leading to a confusion about the date of his death.

In 1630, Giulio, Alessandro, Matteo, and Giovanni Francesco Sacchetti divided among themselves the family properties, deciding to leave the family art collection intact. In 1633 the Sacchetti became Marquises of Castel Rigatti (from 1665 of Castel Romano) and members of the Roman aristocracy. In 1639 Giovanni Battista, the first son of Matteo, was born, and from this year also dates the oldest inventory of the Saccetti collection, listing 295 paintings, among them masterpieces such as the *Sacrifice of Polyxena* and the *Rape of the Sabines* by Pietro da Cortona, and paintings in this exhibition (see cats. 3 and 21). Beginning in 1637, Cardinal Giulio was in Bologna, where he became (as did his brother Alessandro) a close friend of Guido Reni. In these years he and Alessandro acquired a wonderful group of Bolognese paintings: among them examples of Reni's last production (the "*Anima Beata,*" *Lucrezia, Cleopatra,* the *Woman with a Crown*) and Guercino's *Cleopatra and Octavianus*. In 1649 they moved to the Sacchetti Palace in Via Giulia, where their descendants still live.

Though rich and powerful, no Sacchetti was ever elected pope; in two conclaves (1644 and 1655) Cardinal Giulio came close, but was defeated by subtle political maneuvering. While enjoying continual papal protection in the following centuries, they never outstripped the position of power and influence they had reached in the first half of the seventeenth century. Their collection, however, kept growing: in the 1688 inventory (made in the year of the death of Giovanni Battista) 714 paintings were exhibited in the Sacchetti palace. Despite this apparent wealth, the Sacchetti acquired onerous debts, so that the grandson of Giovanni Battista (who had the same name) was forced to sell his collection. Cardinal Silvio Valenti Gonzaga negotiated the sale, and the 187 Sacchetti paintings were valued on December 13, 1747, at 36,709 scudi. Even so, Benedict XIV and Cardinal Valenti Gonzaga refused to pay more than 25,000 scudi; with few

alternatives, the Sacchetti accepted the papal offer, signing the sale document on January 3, 1748. The only important painting that remained in what had been one of the most important Roman collections was the *Portrait of Cardinal Giulio Sacchetti* by Pietro da Cortona.

The history of the Pio family is in stark contrast to that of the Sacchetti. The Pio were of princely origin and numbered courtesans, cardinals, and ambassadors. From 1450 they became "Pio di Savoia" because of a link with the dukes of Savoy, but their land was Carpi, an Emilian town that they owned until the sixteenth century. They then transferred to Ferrara, where they were close to Este family, dukes of the city, and, in the early seventeenth century, to Rome. Carlo Emanuele (1585 – 1641) was created cardinal in 1604, when he was only nineteen years old, and he assembled a well-known collection of paintings. He acquired paintings on the open market (such as *The Fortune Teller* and the *St. John* by Caravaggio, and the *St. Sebastian* by Guido Reni; see cats. 2 and 12) and from Ferrarese collections upon the absorption of Ferrara into the Papal States in 1598, such as the *Holy Family* by Dosso Dossi (cat. 5). The 1624 inventory of his collection listed some seventy-five paintings, but there were many more at the time of his death.

After a few years, Carlo Emanuele's heir and nephew, Carlo Francesco (1622 – 1689), came to Rome and became cardinal, enlarging the collection that was housed in a palace near Campo de' Fiori. The other members of the Pio di Savoia family had started to live outside Rome and simply ignored the collection, which by 1724 included 577 paintings. In 1750, the young prince Giberto, who was living in Paris, asked Pope Benedict XIV for permission to take to Spain the Pio di Savoia paintings. Permission was given, on the condition that Cardinal Silvio Valenti Gonzaga be allowed to chose, in the words of the Pope, "some paintings for our service." Undoubtedly Valenti Gonzaga took this task seriously: he selected 128 paintings—surely the cream of the collection. Among them, apart from the

already mentioned masterpieces of Caravaggio and Reni, were works such as the *Baptism of Christ by Titian*; the *Allegories* by Veronese (cats. 19 and 20); the *Finding of Romulus and Remus* by Peter Paul Rubens; the *Sibyl* by Domenichino (cat. 4); the *Self-Portrait* by Velázquez (cat. 18); and several Ferrarese paintings by Garofalo (see cat. 6), Scarsellino (cat. 14), and Mazzolino.

During the first century of its existence the Picture Gallery was distinct from the Capitoline Museum, the collection of antiquities that had been founded in 1471 and that had been officially opened in 1734. The Museum had its own President, usually a nobleman, and administration, as we know from documents now in the Capitoline Archive. It is not clear, however, to which administration the Picture Gallery belonged in the second half of eighteenth century. One of the classes of the Academy of St. Luke, the accademia del nudo (School of the Nude), was held in a specially designed circular room on the second floor of the Capitoline; here the students could draw from live male models. Contemporary mores prevented the study of female nudes, for which the students availed themselves of the many examples in the pictures gallery: *Susanna and the Elders* and *David and Bathsheba* by Palma il Giovane, or the copies of Raphael's frescoes of Psyche in the Villa Farnesina, or the *Triumph of Galatea*, painted by Pietro da Cortona around 1625. As a result of this close link between the Academy and the Picture Gallery, the Academicians may have acted as curators of the picture collection.

In 1802 Antonio Canova, the well-know sculptor, was made director of fine arts. He started a new policy for Roman public museums (in the second half of the eighteenth century the Vatican Museum had been created) by which funds were derived from the state lottery. After the departure of the French from Rome in 1814, he reorganized the Capitoline Picture Gallery, installing the great altarpiece by Guercino of *The Burial of St. Petronilla*. As a consequence about ninety paintings were transferred later to the Vatican Picture Gallery or to the Academy of St. Luke. In this period the picture gallery was under the administration of the Vatican and in 1839 it passed to the Apostolic Chamber. In 1847 the Capitoline Museum and the Picture Gallery were transferred to the City of Rome by Pope Pius IX.

Sergio Guarino
Curator
Pinacoteca Capitolina

Selected Bibliography

XVIII-XIX century catalogues:
R. Venuti, *Accurata, e succinta descrizione topografica e istorica di Roma moderna, Opera postuma*, Rome 1766, III.
A. Tofanelli, *Catalogo delle sculture antiche e de quadri esistenti nel Museo, e Gallerie di Campidoglio*, Rome 1817.
P. Righetti, *Descrizione del Campidoglio*, I, Rome 1833; II, Rome 1836.
A. Venturi, "La Galleria del Campidoglio," *Archivio Storico dell'Arte*, II, 1889, pp. 441-454.

on the history of the picture gallery:
C. Pietrangeli, "Nuovi lavori nella più antica pinacoteca di Roma," *Capitolium*, XXVI, 1951, pp. 59-71.
S. Guarino, "La Pinacoteca Capitolina dall'acquisto dei quadri Sacchetti e Pio di Savoia all'arrivo della Santa Petronilla del Guercino," in *Guercino e le collezioni capitoline*, exh. cat. Roma 1991-1992, pp. 43-62.
S. Guarino, "Ricerche sulle collezioni pittoriche del Campidoglio e del Vaticano nei primi decenni dell'Ottocento," *Roma moderna e contemporanea*, I, 1993, pp. 81-94.

modern guides:
R. Bruno, *Pinacoteca Capitolina*, Bologna 1978.
A. Mura Sommella - M.E. Tittoni Monti, *Masterpieces of the Capitoline Museum*, Rome 1996.

on the Sacchetti:
J. Merz, *Pietro da Cortona*, Tübingen 1991, pp. 76 – 103.
I. Fosi, *All'ombra dei Barberini - Fedeltà e servizio nella Roma barocca*, Rome 1997.
Pietro da Cortona, il meccanismo della forma, exh. cat., Rome 1997.

on the Pio di Savoia:
Quadri rinomatissimi: il collezionismo dei Pio di Savoia, ed. J. Bentini, Modena 1994.

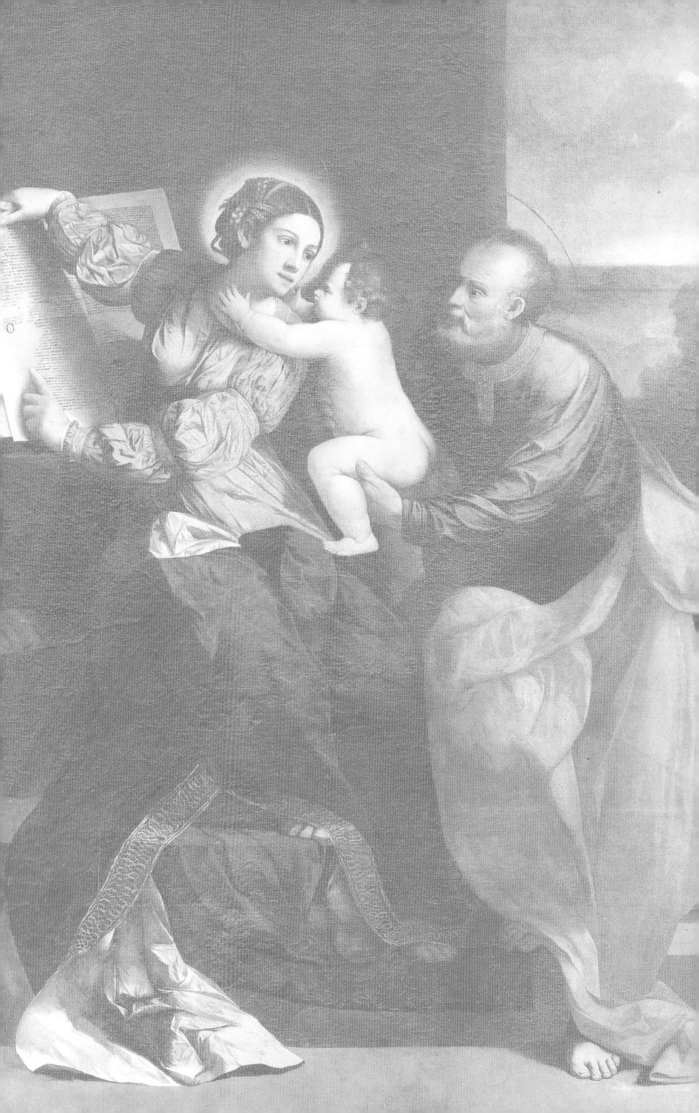

Commentaries

Denys Calvaert

Antwerp? c. 1540 - Bologna 1619

According to a document of 1556, Calvaert was in Antwerp then as an apprentice to Cerstiaen van de Queborn, a landscape painter. When Calvaert was about twenty years old, he moved to Bologna, where he remained until his death. In Bologna he worked as an assistant to Prospero Fontana and later to Lorenzo Sabatini. He accompanied Sabatini to Rome in 1572, where they collaborated on the frescoes in the Sala Regia of the Vatican Palace. Upon his return to Bologna in 1575, he opened a school attended by many important painters of the next generation, including Guido Reni, Domenichino, and Francesco Albani.

1.
The Mystic Marriage of St. Catherine, 1590
oil on canvas, 94 x 70 cm (37 x 27-1/2 in.)
Capitoline inv. 99
provenance: Sacchetti

The theme of the mystical wedding of St. Catherine and the infant Jesus was cherished in Emilian painting in the sixteenth century. Catherine, daughter of King Costus of Alexandria, had refused to marry the pagan Emperor Maxentius, declaring that she was already the bride of Christ. Calvaert's painting shows Catherine symbolically marrying the young Jesus, who hands her a ring. The attributes lying at the feet of the saint (the crown and the palm) remind us of her royal birth and her martyrdom. St. Anne, mother of the Virgin, and the young St. John the Baptist also are present.

The signature and date under the cradle on which Christ sits are only partially legible today: "Dionisi Cal. . . . 1590."

The miraculous event takes place in a grand edifice, through which a landscape is seen, recalling Calvaert's youthful training. Calvaert's clear colors also derive from the Flemish tradition. The oblique arrangement of figures, their histrionic poses and magnificent draperies show Calvaert's command of Mannerism, the highly contrived, artificial style practiced at the time by artists in Italy and throughout Europe. The intimacy of the mystical moment is thereby somewhat compromised.

A drawing in the Louvre (inv. 19836) suggests that the original idea for the composition was even more complex, with angels flying in the sky and young St. John in the foreground.

PM

1.

Bibl.: S. Bergmans in exh. cat. Bruxelles 1963, p. 77, nr. 64; N. Dacos in exh. cat. Rome 1995, pp. 116-117 (with previous bibl.).

Caravaggio

(Michelangelo Merisi da Caravaggio)
Milan 1571 - Porto Ercole 1610

Caravaggio studied in Milan with the
Lombard painter Simone Peterzano. In 1592
he was in Rome working as a still life
specialist in the workshop of Giuseppe
Cesari, the Cavalier d'Arpino. He soon met
Cardinal del Monte, a sophisticated art
collector, who became his first protector.
During these years, Caravaggio carried out
works for private collectors and became
famous for the shocking novelty of his
painting. His first public works were the
paintings for the Contarelli Chapel in the
church of San Luigi dei Francesi (scenes
from the life of St. Matthew, c. 1597-1601)
and for the Cerasi Chapel in Santa Maria
del Popolo (*Crucifixion of St. Peter* and
Conversion of St. Paul, c. 1601). In 1606,
accused of homicide, he fled Rome. He
wandered from Naples, to Sicily, to Malta,
where he carried out his last works. He died
on the beach at Porto Ercole on July 18,
1610, while en route to Rome to receive a
papal pardon.

2.

St. John the Baptist or *Isaac*, c. 1600
oil on canvas, 129 x 95 cm (50-3/4 x 37-1/2 in.)
Capitoline inv. 239
provenance: Pio di Savoia

A youth, sitting on a sheep fleece above some foliage, em-
braces a ram while turning to look cheekily at the spectator.
Although it has been in a public collection since the middle of
the eighteenth century, this unsettling picture only emerged in
1953 as an autograph painting by Caravaggio. It was redis-
covered then by the English scholar Denis Mahon, who saw
it hanging in the office of the Mayor of Rome. Thanks to
Mahon's efforts, and the intervention of Carlo Pietrangeli,
then director of the Capitoline Museum, the picture was
returned to the Gallery from which it had been removed
because it was thought to be a copy. Since then, intense study
of the picture (see the summary in Tittoni 1990; see also
Guarino 1995, for the rich bibliography on the painting)
has led to a scholarly consensus that favors an attribution
to Caravaggio and clarifies the painting's relationship with
a version in the Doria Pamphilj Collection in Rome
(see Identificazione di un Caravaggio, 1990).

The identification of the subject has also been much discussed.
Contemporary documents do not offer a clear identification
(see Varoli Piazza, 1990). The interpretation of the subject as
St. John the Baptist is supported by the identity of the patron,
whose son's name was John; another interpretation suggests
that the youth is a "Pastor friso," the Trojan prince, Paris, a
classical literary subject (for these interpretations see,
respectively, Guarino, 1995, and Gilbert, 1995). Both
hypotheses are problematic: John the Baptist's traditional
attribute is a lamb, not the ram so prominently displayed
here; and a classical subject seems out of keeping with the
Christian subjects of other works that Caravaggio painted for
the same patron. The recent proposal by Liliana Barroero
(1997) has probably solved the problem. She identifies the
subject as the Old Testament figure Isaac, who was saved by
the Lord from being murdered by his own father, Abraham, in
a test of faith (Gen. 22:1-19). According to Barroero, the
Capitoline picture shows Issac in the act of rising from the
pyre, where, in a short time, the ram will be sacrificed in his
stead. The sacrifice of Isaac was understood to foreshadow
the sacrifice of Christ on the Cross (in keeping with this
interpretation, the vine leaves seen at the right would refer
to the wine of the Eucharist).

The picture was painted for Ciriaco Mattei, a prominent
collector and member of an important Roman family (see
Caravaggio e la collezione Mattei, 1995); for him Caravaggio
also painted the *Supper in Emmaus* (London, National

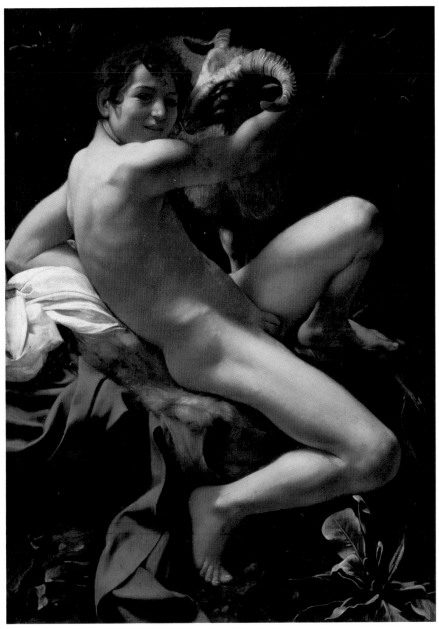

2.

Gallery) and the recently discovered *Arrest of Christ* (Dublin, National Gallery of Ireland). The *St. John/ Isaac* may be the work— whose subject is not indicated—for which the artist was paid on June 26 and December 5, 1602 (see Cappelletti-Testa 1994, pp. 137-141, nos. 33 and 49: the two authors published the documents in 1990). The painting passed to Ciriaco's son, Giovanni Battista, and was later left as a legacy to Cardinal del Monte; after the latter's death, it was sold on May 5, 1628. It was bought, together with other paintings-including *Saint Sebastian* by Guido Reni (cat. 12)—by the Pio family, and since 1750 has been in the Capitoline Picture Gallery.

Critical comments about this extraordinary painting note Caravaggio's ingenious use of light and his uncanny ability to combine vivid realism with profound religious emotion. For all of his novelty, however, Caravaggio was mindful of past art: the pose of the youth clearly is derived from the nude youth painted by Michelangelo on the left of the Eritrean Sibyl on the ceiling of the Sistine Chapel. Another model may have been the allegorical figure by Guido Mazzoni in the Palazzo Spada-Capodiferro in Rome (see Calvesi, 1985).

SG

Bibl.: Mahon 1953, p. 213, note 7; D. Mahon - D. Sutton in exh. cat. London 1955, nr. 17, pp. 20-24; Marini 1974, pp. 382-385; Cinotti 1983, nr. 59, pp. 521-523 (with previous bibl.); Calvesi 1985, pp. 276-280; Marini 1987, nr. 40, pp. 444-446 (with previous bibl.); Tittoni 1990, pp. 11-14; Varoli-Piazza 1990, pp. 33-45; L. Testa in Cappelletti-Testa 1994, nr. 9, pp. 195-206; S. Guarino in exh. cat. Rome 1995, pp. 120-123 (with previous bibl.); Gilbert 1995, pp. 1-61 and 249-256; Barrroero 1997, pp. 37-41.

Pietro da Cortona

(Pietro Berrettini)
Cortona 1597 - Rome 1669

Pietro da Cortona moved to Rome at a very young age, following his master Andrea Commodi; later, he joined the workshop of the Tuscan painter Baccio Ciarpi. Starting in 1622, Pietro collaborated on the decoration of the gallery in the Palazzo Mattei. Shortly thereafter he met the banker Marcello Sacchetti, who was to become his first and most important patron. He carried out many works for Sacchetti, including the fresco decoration of Castel Fusano and the monumental *Rape of the Sabine Women*, today in the Capitoline Gallery. In 1632, he started the fresco decoration for the great ceiling of the Palazzo Barberini in Rome. Beginning in 1637, he worked in Florence on the frescoes of Palazzo Pitti, an enterprise which lasted for several years. Returning to Rome, he was active as a painter and architect. In 1651, on orders of Pope Innocent X, he decorated the gallery of the Palazzo Pamphilj.

3.
The Tolfa Alum Mines, c. 1630
oil on canvas, 61 x 75 cm (24 x 29-1/2 in.)
Capitoline inv. 85
provenance: Sacchetti

In August 1626, the banker and art collector Marcello Sacchetti was granted the right to the alum mines in the Tolfa mountains, about 100 kilometers (sixty miles) north of Rome, by Pope Urban VIII. Alum was used in tanning skins, and the quarry produced handsome profits. The papal concession lasted for twelve years; after the death of Marcello Sacchetti in 1629, it passed to his brothers as a legacy.

Landscape had long been depicted in painting, but only at the beginning of the seventeenth century did it emerge as an independent subject in the works of Bolognese painters working in Rome. The series of six paintings (the "Aldobrandini lunettes") by Annibale Carracci and his pupils, which had been commissioned by Cardinal Pietro Aldobrandini around 1601 for a chapel in the Aldobrandini Palace, was instrumental in establishing the genre of the "ideal landscape." As seen in the first and most famous of the group, the *Landscape with the Flight to Egypt*, painted by Annibale (maybe with the aid of Domenichino), nature is depicted as harmonious and hospitable to human action. Today, the six lunettes are in the Doria-Pamphilj Gallery in Rome.

Pietro da Cortona's subject here is not ideal but real. He paints a specific and well-known site (it is, in fact, the "Great Quarry" of the mines), animated by mineworkers. Pietro employs broad handling and soft contours and does not dwell on details, however. His free brushwork indicates a date later than the traditional one of 1629, linked to the patronage of Marcello Sacchetti. In fact, the artist could have painted it in the early 1630s for Marcello's brothers (and successors at the mine): Cardinal Julius, Alexander, and Matthew. It is possible that the three figures on the left are the three brothers, visiting the mines with their entourage.

SG

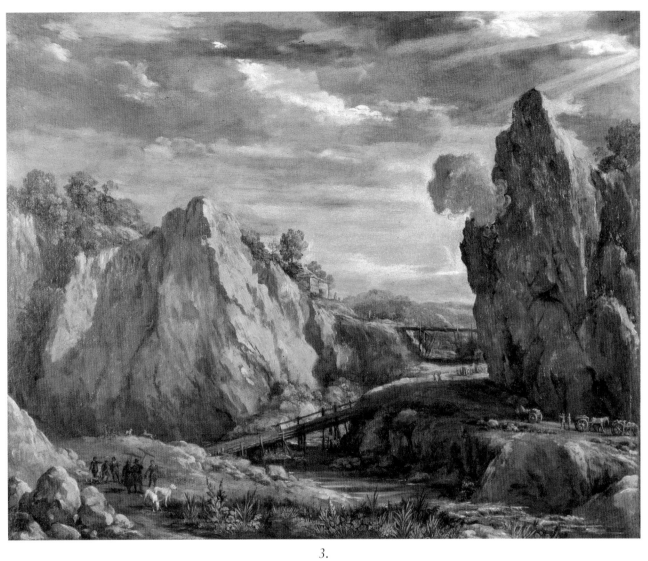

3.

Bibl.: Briganti 1962, p. 182, nr. 27; Merz 1991, p. 304; S. Guarino in exh. cat. Rome 1997-98, p. 328, nr. 31 (with previous bibl.)

Domenichino

(Domenico Zampieri)
Bologna 1581 - Naples 1641

Domenichino studied in Bologna with Denys Calvaert and later with Ludovico Carracci. Joining Annibale Carraci's Roman workshop in 1602, he collaborated on the frescoes of the Palazzo Farnese. When Guido Reni returned to Bologna, Domenichino became the leading painter in the classical style in Rome and the executant of important commissions, including the Polet Chapel in the church of San Luigi dei Francesi (St. Cecilia cycle, 1612-1615) and, perhaps his best work, the frescoes in the apse of the church of Sant'Andrea della Valle (1623-1628). In 1631 he moved to Naples where he worked in the San Gennaro Chapel of the Cathedral.

4.

Sibyl, 1622
oil on canvas, 138 x 103 cm (54-1/4 x 40-1/2 in.)
Capitoline inv. 134
provenance: Pio di Savoia

Pagan sibyls have been linked with Old Testament prophets since the Middle Ages, because through them God spoke to the Gentiles, just as through the prophets He spoke to the Jews. Most famously, the Tiburtine Sibyl prophesied to the Emperor Augustus the coming of an age of peace, understood as the Christian epoch, and the Cumean Sibyl promised a "new progeny from heaven" that would initiate a "return of the Golden Age." Michelangelo, for example, paired prophets and sibyls on the Sistine ceiling.

Sibyls were often depicted by the leading painters of the Bolognese school (Domenichino, Reni, Guercino) in the early seventeenth century. Conforming to visual tradition, the Capitoline's *Sibyl* is shown richly dressed, with a wide, oriental-like turban and an open book. The Greek writing on the half-furled roll that she holds reads: "There is a unique, infinite and unborn God." These words, foretelling a God not yet born, are clearly prophetic. The vine plant that can be seen behind the wall probably refers to Christ.

The first sybil painted by Domenichino (1617) was in the collection of Cardinal Scipione Borghese, one of the most important patrons and art collectors in Rome. According to the documents, the Capitoline's *Sibyl* was painted a few years later, in 1622, for the Bolognese Senator Girolamo Albergati, and very soon was purchased by Cardinal Carlo Emanuele Pio, in whose inventory of 1641 it appears. The painting is known in two further versions (in the Wallace Collection in London and an English private collection), both of which are considered autograph by critics. X-ray examination of the Wallace Collection picture has revealed that the artist made changes in design (*pentimenti*), which suggest that it was the first one to be painted. X-ray examination of the Capitoline painting and the private collection picture, which at one time belonged to the Bolognese Ratta family, indicate precise underdrawing, undoubtedly taken from a model or a cartoon.

As in the Borghese's *Sibyl*, the Capitoline's *Sibyl* is strongly idealized and recalls Raphael's canon of feminine beauty. But here the volumes are exaggerated and the brush strokes are broad and free, especially in the drapery. The same largeness of form and facture is seen in the artist's great decorative enterprise, the apse decoration of Sant'Andrea della Valle, a magnificent example of Baroque classicism.

PM

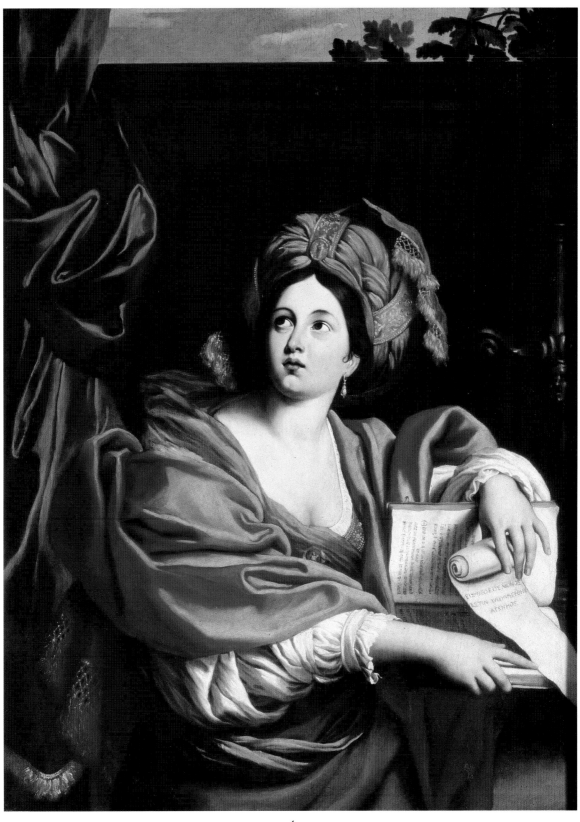

4.

Bibl.: Spear 1982, I, pp. 232-233 (with previous bibl.); R. Spear - H. Brigstocke in exh. cat. Rome 1996-97, p.452 nr. 40.

Dosso Dossi
(Giovanni Luteri)
Mirandola? 1486/1487 - Ferrara 1542

We have no information on Dosso's training. In 1512 he worked in Mantua, and in the next year he collaborated with Garofalo on the high altarpiece for the church of Sant'Andrea in Ferrara. He often traveled to Venice, where he studied the paintings of Giorgione and the young Titian, with whom he was acquainted. Starting in 1514, and throughout his career, Dosso worked for the dukes of Ferrara, Alfonso I d'Este (duke 1505-1534) and Ercole II d'Este (duke 1534-1559). In 1531, together with his brother Battista, he worked at Trento, in the castle of Buonconsiglio.

5.
Holy Family, c. 1527-1528
oil on canvas, 236 x 171 cm (92-3/4 x 67-1/4 in.)
Capitoline inv. 1
provenance: Pio di Savoia

The subject of the *Holy Family* has been interpreted in many different ways. In this case, Saint Joseph hands the Infant Christ to the Virgin, who turns her gaze away from a richly illuminated book. The monumental poses of Mary and Joseph are humanized by Dosso's depiction of a tender emotional exchange: the Virgin's affectionate gaze towards her Son, Jesus' outstretched arms, and Joseph's supportive hands.

This painting first appeared in the inventories of the Pio collection in 1624. Its original location is not known, but it is likely that it was painted for a church in Ferrara. In 1598 Ferrara lost its independence and became part of the Papal States; many works of art were removed from churches, monasteries and private collections and eventually appeared in important Roman collections. In a 1750 inventory of the Pio collection the painting was attributed to the Venetian painter Palma il Vecchio. Only at the end of the nineteenth century was Dosso's authorship reestablished.

A precise date for the *Holy Family* is difficult to determine. While influences from the works of Giulio Romano, then working in Mantua, are evident, the head of the Madonna is similar to the head of a female figure in another painting by Dosso, the *Allegory with Pan* in the Getty Museum, datable around 1529-1532. For these reasons, in 1993 Alessandro Ballarin proposed a date for the Capitoline Gallery's painting of around 1528.

In the recent catalogue of the exhibition *Dosso Dossi, Court Painter in Renaissance Ferrara* (1998-1999), Peter Humfrey, pursuing earlier ideas of Longhi and Mezzetti, proposed that Battista Dossi may have collaborated with his brother in the execution of the picture. The figure of Saint Joseph (especially the head, which seems less accomplished than that of the Virgin) is perhaps Battista's contribution.

SG

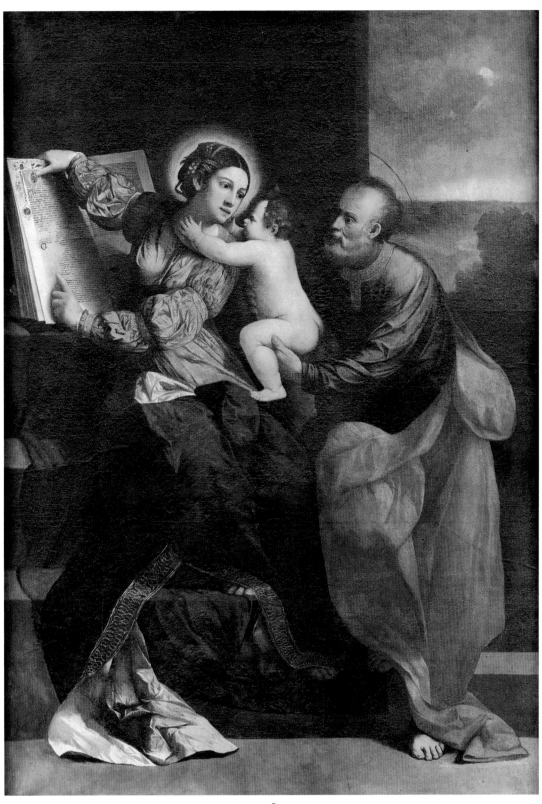

5.

Bibl.: Mezzetti 1964, pp.113-114, nr. 165; Gibbon 1968, p. 202, nr. 62; A. Ballarin in exh. cat. Paris 1993, p. 422; P. Humfrey in exh. cat. Ferrara–New York–Los Angeles 1998-99, pp. 191-193 (with previous bibl.).

Garofalo

(Benvenuto Tisi)

Ferrara 1481-1559

Beginning in 1497, Garofalo studied
in Ferrara with the Cremonese painter
Boccaccio Boccaccino. In 1500 he visited
Rome and returned there in 1512 to study
the works of Raphael. In the interim he
also visited Mantua (1506) and Venice.
After settling in Ferrara, he produced
many pictures, including altarpieces,
for churches and convents in the city and
the surrounding area.

6.

Annunciation, c. 1528

oil on canvas, 103 x 132 cm (40-1/2 x 52 in)

Capitoline inv. 5

provenance: Pio di Savoia

In this traditional scene of the Annunciation, the Archangel Gabriel, who is magnificently dressed and holds three lilies, addresses the Virgin Mary, who kneels before a lectern decorated with a sphinx. At the upper left are God the Father and the Infant Jesus, who holds out the instruments of the Passion (the Cross and the Column of the Scourging). In the center, the dove of the Holy Spirit hovers before two columns which rest on a plinth decorated with a bas-relief. To Mary's right we can see a domestic interior, with a lit fireplace, and a cat. The date is inscribed on the fireplace: MDXXVIII MAI (May 1528). The three carnations (in Italian, *garofano*) in a small vase are a clear reference to the painter's nickname, Garofalo.

The *Annunciation* was painted for the chapel of the infirmary of the San Bernardino monastery in Ferrara, for which Garofalo produced many works without compensation. By 1641 it had entered the Pio collection, its place in the monastery taken in 1753 by a copy (recorded as the original) by the painter Giuseppe Ghedini.

In the *Annunciation*, we can observe the most characteristic elements of Garofalo's style, with its blend of Venetian color and Raphael's sculptural figure style. The central columns divide the scene in two parts, which are united by the diagonal arrangement of forms directing attention to the Virgin. The magnificent and vivid colors of the angel's dress contrast with the simple humility of Mary's pose, indicating her acceptance of the divine will.

SG

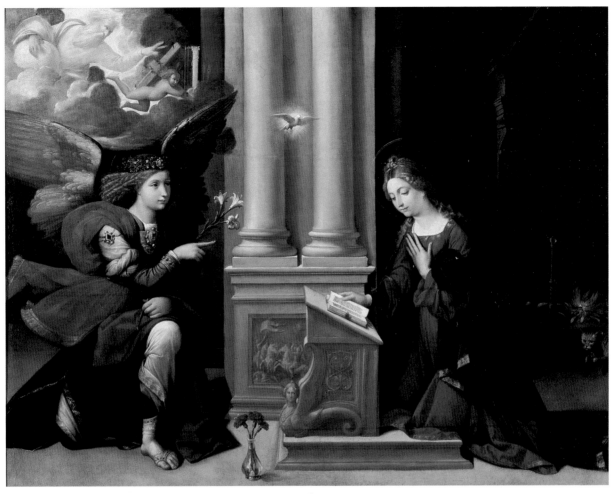

6.

Bibl.: Neppi 1959, pp.32, 54; Fioravanti Baraldi 1993, pp. 203-205, nr. 134. (with previous bibl.).

Guercino

(Giovanni Francesco Barbieri)
Cento 1591- Bologna 1666

Guercino studied the works of the Carracci (particularly Ludovico) and the Ferrarerese and Venetian painters Dosso Dossi, Scarsellino, and Titian. In 1621, the Bolognese pope, Gregory XV Ludovisi, called him to Rome where he decorated the Casino Ludovisi (*Aurora*) and painted the *Burial of St. Petronilla*, an altarpiece for Saint Peter's (Rome, Pinacoteca Capitolina). In 1623 he went back to Cento, where he soon became one of the leading Italian artists of the seventeenth century. He moved to Bologna in 1642 after the death of Guido Reni, becoming head of that important regional school.

7.

St. Matthew and the Angel, 1622
oil on canvas, 120 x 179 cm (47-1/4 x 70-1/2 in.)
Capitoline inv. 55
provenance: Pio di Savoia

According to tradition, Matthew was the apostle who wrote the first book of the Gospel. His symbol, derived in the first centuries of Christianity from a passage by Ezekiel (1:5 -14), was a winged man, soon transformed into an angel. In modern iconography, the angel dictates to Matthew the text of the Gospel.

The English scholar Denis Mahon has dated this painting to Guercino's brief Roman period, because of similarities to other pictures painted during that time, such as the *Burial of St. Petronilla* for St. Peter's, the *Magdalene,* for the church of the Convertite al Corso (now Rome, Pinacoteca Vaticana), and the *Glory of St. Crisogono* for the church of San Crisogono (now at Lancaster House, London). Final payment made between June and October 1622 for this last painting date it precisely. By 1641 the *St. Matthew* was listed in the inventory of the Pio family, but we do not know for whom Guercino painted it.

The restoration of the painting was completed in February 1999. While exposing damages from previous restorations, the cleaning also removed a thick layer of dark varnish and revealed the background and the dramatic modeling of the surfaces from the light source in the upper left. The figures of the old man and the angel are set one against the other in an almost formulaic way, contrasting the human and the divine.

Denis Mahon has remarked how in the *St. Matthew* Guercino has partially modified his youthful style of soft contours and ambiguous space. This painting is more sculpturesque, but a close viewing shows the singular fluidity of the rapidly applied brushstrokes, especially in the details. Some passages, such as the wings of the angel, record the artist's vigorous facture; while others (such as the still life on the top left, the wall of the background, and the mat and the clothes on which the evangelist lies) faithfully describe appearances. The picture is thus transitional between his early work and the sculptural conception of form visible in the St. Petronilla altarpiece.

PM

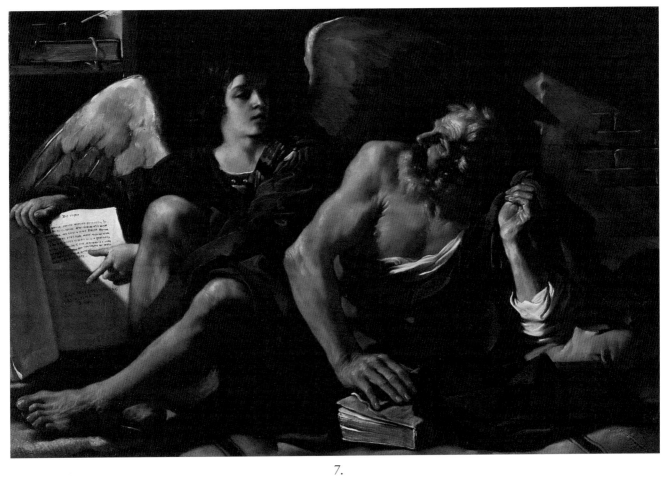

7.

Bibl.: D. Mahon in exh. cat. 1968, p. 121, nr. 50; Salerno 1988, p. 172, nr. 89; Stone 1989, p. 371; P. Masini in exh. cat. Rome 1991-92, p. 16 nr. 2; Stone 1991, p. 106 nr. 83.

Lorenzo Lotto

Venice c. 1480 - Loreto 1556

Born in Venice, Lotto worked almost his
whole career outside his native city. As a
youth, he worked in Treviso and in the
Marches, painting mainly religious sub-
jects. After a short stay in Rome, he moved
to Bergamo, where he worked for the local
wealthy bourgeoisie. In 1525 he returned
to Venice, but the dominance of Titian
prevented him from making a reputation.
He was forced to move back to the
Marches where he died in poverty.

8.

Portrait of a Crossbowman, 1551-1552
oil on canvas, 94 x 72 cm (37 x 28-1/2 in.)
Capitoline inv. 40
provenance: Pio di Savoia

The sitter, wearing an austere dark suit, is portrayed
three-quarters, bending slightly as he stands a crossbow
on a table.

The painting probably comes from the Pio collection,
although it cannot be identified with certainty in the invento-
ries of the seventeenth and eighteenth centuries. In the past, it
was attributed to Giorgione but, in 1892, Giovanni Morelli
recognized it as a work by Lotto. It is undoubtedly the
portrait of a crossbowman that is listed by the painter in his
account book in November 1551. The entry identifies the
sitter as Battista di Rocca Contrada (Rocca Contrada was
the sixteenth-century name of Arcevia in the Marches).

In 1549 Lotto had moved from Venice to Ancona. He soon
found himself in bad straits and was struggling to survive
(Zampetti). In 1550 he tried to auction several of his paint-
ings and drawings, hoping to earn 400 scudi, but sold only
seven works for less than forty scudi. The circumstances
under which the *Portrait of a Crossbowman* was painted
reveal his distressed situation: valued in the account book at
eight scudi, the painter ultimately was paid in kind, with
frames or "ornaments."

Most of Lotto's works done during his Ancona stay are lost.
Therefore, the portrait is an important example of his late
style, characterized by a direct realism.

SG

30

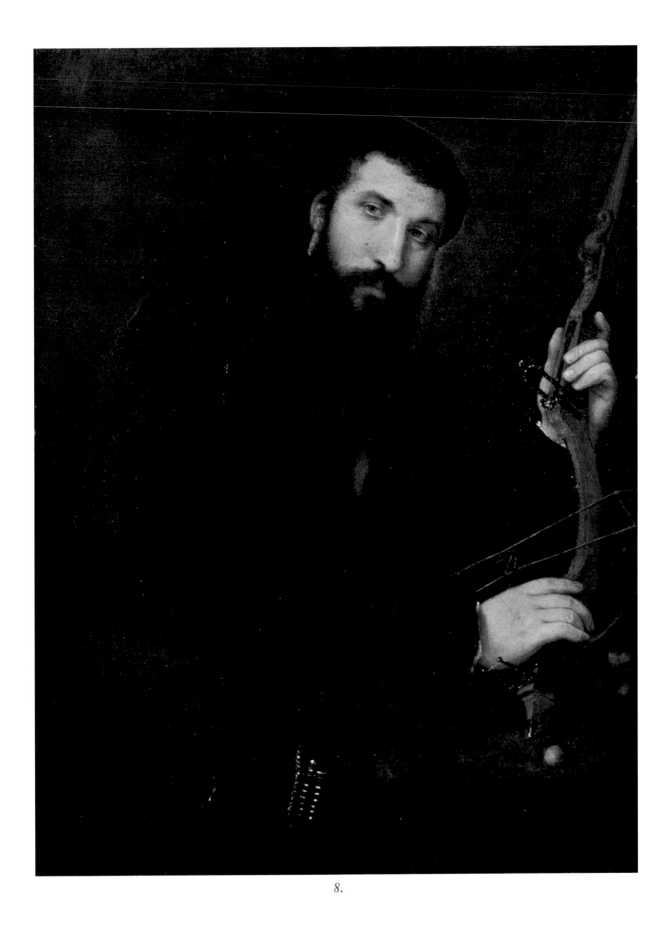

8.

Bibl.: P. Zampetti in exh. cat. Ancona 1981, p. 453 (with previous bibl.); Bonnet 1996, pp. 172, 198.

Gabriel Metsu

Leyden 1629 - Amsterdam 1667

After studying with Gerrit Dou, Metsu joined the Painters' Guild of Leyden in 1648. In 1657 he moved to Amsterdam, where be became familiar with the works of Rembrandt, Vermeer, and Pieter de Hooch. He specialized in allegorical and religious scenes, and in genre painting, rendered in a precise, descriptive style. Over the course of time, his colors became brighter, and he abandoned the darker tonalities typical of his youthful paintings.

9.

Crucifixion, after 1657

oil on canvas, 73 x 56.8 cm (28-3/4 x 22-3/8 in.)

Capitoline inv. 253

provenance: bequest of A. Torlonia, 1926

This small devotional painting entered the Capitoline Picture Gallery collection in 1926 as a legacy from Augusto Torlonia. It is one of the few examples of a non-Italian artist's work in the collection.

The painting shows another side of Metsu's production, which is largely devoted to precisely rendered indoor scenes. In the early Leyden period of his activity, however, Metsu had concentrated on classical and religious subjects. The Capitoline's painting shows the Crucifixion as a night scene. The light breaks in from the top right and illuminates the body of Christ, the Virgin Mary, Mary Magdalene and St. John at the bottom of the cross. The colorful robes emerge from darkness and stand out like silhouettes from the background. The Magdalene's swoon animates the composition of vertical elements, while the ointment jar that she used when she perfumed the feet of Christ during the supper in the house of the Pharisee (Luke 7: 35-50) anchors the swath of white drapery in the foreground. The emotional Rembrandtesque elements lead us to date the painting after Metsu's move to Amsterdam.

PM

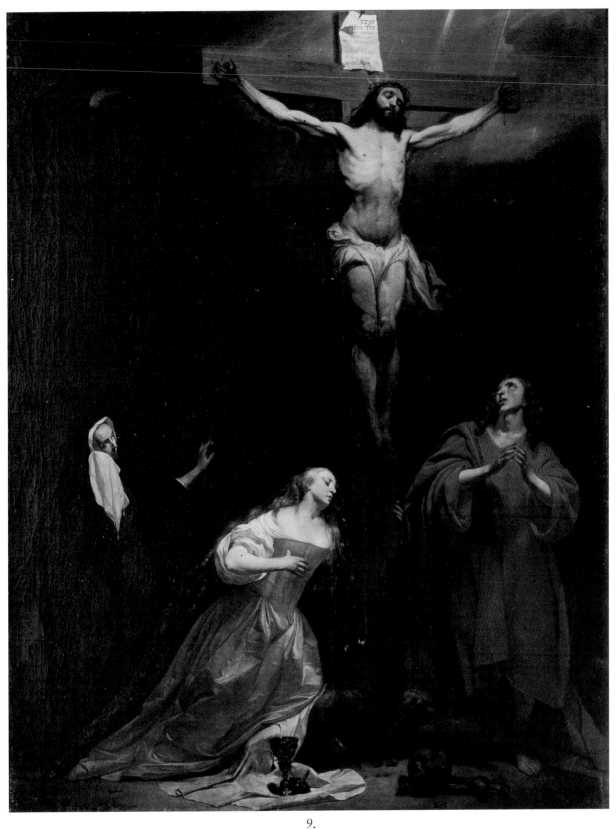

9.

Bibl.: Bruno 1978, p.81

Pier Francesco Mola

Coldrerio-Ticino 1612- Rome 1666

Mola arrived in Rome as a child with his father, Giovanni Battista, an architect. He spent his life in Rome, interrupted only in the 1630s and l640s. His style reveals a profound knowledge of sixteenth-century Venetian art and of Italian contemporary painting. Mola went back to Rome at the end of the 1640s. He received important commissions from the Pamphilj family, and collaborated on the decoration of the Alexander VII Gallery in the Quirinale Palace.

10.
Endymion, after 1647
oil on canvas, 148 x 117 cm (58-1/4 x 46 in.)
Capitoline inv. 146
provenance: Pio di Savoia

Endymion has been widely depicted in painting since the sixteenth century, inspired not only by ancient Greek and Roman literary sources (Apollonius of Rhodes, Apollodorus, Pausanias, Lucian), but also by classical art. Several versions of the myth of Endymion exist. The chaste goddess of the moon, Diana, falls in love with the beautiful young shepherd and embraces him while he sleeps: for this reason, Endymion wishes to sleep all the time. Diana obtains from Jupiter immortality, eternal youth, and endless sleep for her beloved.

Mola painted this Endymion for his friend, Bonaventura Argenti, a musician in the Pontifical Chapel and a refined collector. As Cocke has suggested, the "modern" visual source is the figure of Endymion painted on the ceiling of the Farnese Gallery by Annibale Carracci in the last years of the sixteenth century. A more immediate source may be the 1647 painting with the same subject by Guercino, which was in the Pamphilj collection in 1652. Mola's painting shares with the Guercino painting its melancholy aura; also derived from Guercino is the nocturnal setting, illuminated by the silvery light of the full moon, against which Diana's ethereal figure hovers. The sleeping youth leaning on his arms, almost a foil to Guercino's figure, is mirrored in the coiled body of the dog, a silent creature that is totally unaware of the divine presence.

Scholars have proposed several dates for the painting: 1640-1650 (Arslan); 1652-1656 (Cocke); 1660 and beyond (Sutherland Harris and Laureati). If we accept Guercino's painting as a reference, the date must be after 1647.

PM

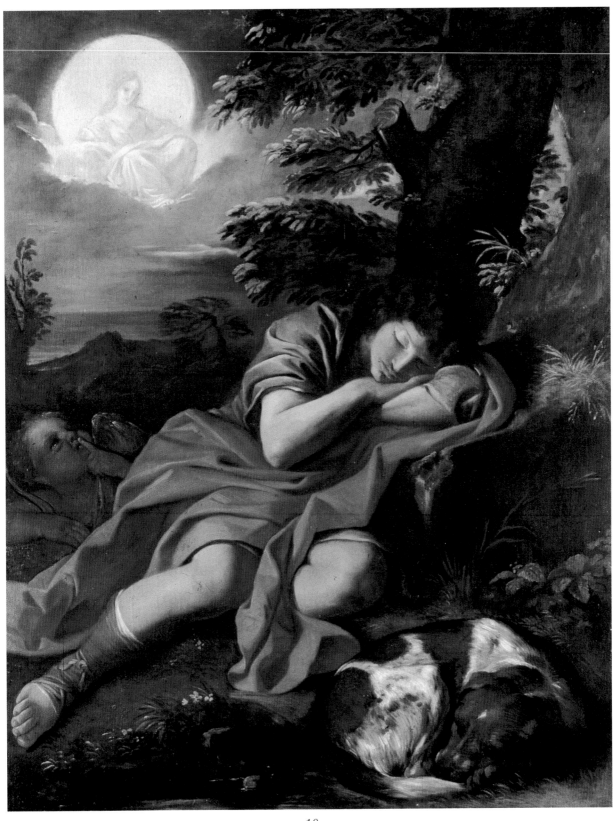

10.

Bibl.: Arslan 1928-29, p. 62; Cocke 1972, pp. 31, 54; Sutherland Harris 1974, pp. 291-292; L. Laureati in exh. cat.
Lugano – Rome 1989-90, p. 187, nr. I.30 (with previous bibl.).

Bartolomeo Passerotti

Bologna 1529 -1592

When he was young, Passerotti lived in Rome, where he worked with Taddeo Zuccari. In 1560 he returned to Bologna, where he soon became a protagonist in the city's cultural life. An eclectic painter and careful collector, he took an interest in the naturalistic studies of Ulisse Aldrovandi and in the program of religious reform of Cardinal Gabriele Paleotti. Passerotti is still famous for his "genre" painting and, in particular, for his skill in painting portraits.

11.

Portrait of a Man with a Dog, c. 1585
oil on canvas, 57 x 46.5 cm (22-1/2 x 18-1/4 in.)
Capitoline inv. 68
provenance: Sacchetti

The sitter is portrayed nearly half-length, wearing a doublet with a ruff and tall headgear. His face is turned towards the spectator, while his left hand supports a dog, which leans on him with its forepaws.

The painting comes from the Sacchetti collection, where it is listed in eighteenth- century inventories as a work by Annibale Carracci, and, later, Antonio Carracci. Even though modern studies correctly assign the painting to Bartolomeo Passerotti, the early citations are telling. The work must be dated around 1585, a time when the relationship between the works of Passerotti and those of Carracci was particularly significant. If Passerotti was well acquainted with Annibale's innovations in Bolognese painting, Annibale for his part studied carefully the works of the older painter, especially his portraits. Annibale imitated the *Portrait of a Man with a Dog* in his 1587 *Portrait of a Musician* (Mazza, 1984; today the painting is in the Capodimonte Museum in Naples). As numerous examples demonstrate, Passerotti had unusual insight into psychological and human traits, and he succeeded in presenting a direct and balanced characterization of his sitters (Ghilardi, 1990).

In the *Portrait of a Man with a Dog*, specific elements of Passerotti's late style can be noticed: the intensity of the unknown man's gaze; the discreet hints at his refinement; and, most of all, the affectionate relationship with the dog, an animal that appears often in the artist's canvases.

SG

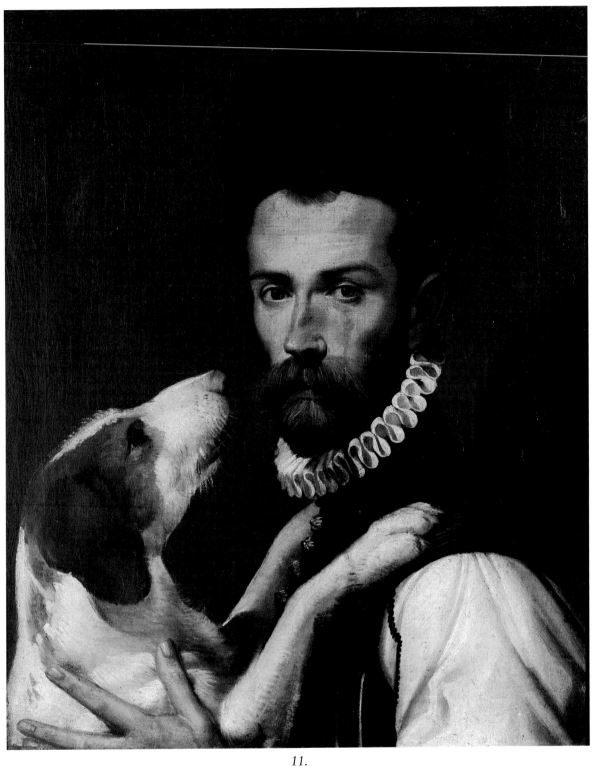

11.

Bibl.: Mazza in exh. cat. Bologna 1984, p.31; Ghilardi 1990, p. 295 (with previous bibl.).

Guido Reni

Bologna 1575 - 1642

Guido Reni studied with Denys Calvaert and then, in 1595, he joined the Carracci Academy in Bologna. Starting in 1599 he traveled between Bologna and Rome, where he undertook several commissions from Pope Paul V and his nephew, Cardinal Scipione Borghese. Guido soon became the leading painter of the classical style in seventeenth century painting, which presented an idealized vision of appearances. He reestablished himself in Bologna, and thereafter left the city only for very short journeys. Around 1630 he turned to paler colors in his work and a more intensely dramatic interpretation of subject matter.

12.
Saint Sebastian, c. 1615

oil on canvas, 128 x 98 cm (50-3/8 x 38-1/2 in.)
Capitoline inv. 145
provenance: Pio di Savoia

This painting epitomizes the style and religious tenor of Guido Reni's works. Eschewing the depiction of mundane reality, the artist expresses an inner vision. The *Saint Sebastian*, which is datable to around 1615, is only one of a remarkable number of works by the artist in the Capitoline Gallery.

Sebastian was an officer of the Praetorian Guard during the reign of Emperor Diocletian (Emperor 284-305 A.D.). He had secretly converted to Christianity and urged two of his Christian colleagues to undergo torture and martyrdom. His faith revealed, Sebastian was condemned to execution by archers, but the arrows which hit him did not kill him.

In this painting, Saint Sebastian stands out almost as a classical statue against the background of a landscape that is animated by small, rapidly stroked figures typical of Bolognese art. The reference to antique sculpture perhaps recalls Sebastian's role as the third patron saint of Rome (after Peter and Paul), and Guido's own career in the city.

Sebastian was a popular subject in Italian painting because it allowed the depiction of a nude male body and because the saint was a protector against the plague. In Guido's sensual interpretation of the theme, the saint's martyrdom is understood as a way of becoming closer to God. This union with the divine is shown above all in the upturned eyes, a distinctive feature of Guido's art that his seventeenth-century biographer, Malvasia, described in a famous passage. The subject appears in an almost identical version in Geona (Palazzo Rosso, c. 1616-1617), in a slightly later painting in the Prado, where the saint's body twists in a remarkable pose, and in a later work in the National Gallery of Bologna. Compared to the Genoa version, the present painting has been almost overlooked by critics (it is not mentioned in the catalogue of the last exhibition devoted to Guido Reni, in 1988). However, a 1977 restoration, directed by Maria Elisa Tittoni, had revealed the excellent quality of the work. In addition, a re-examination of some documents published in 1971 (concerning Caravaggio) confirmed the attribution. These documents are related to a sale of paintings belonging to Caravaggio's patron, Cardinal del Monte, which took

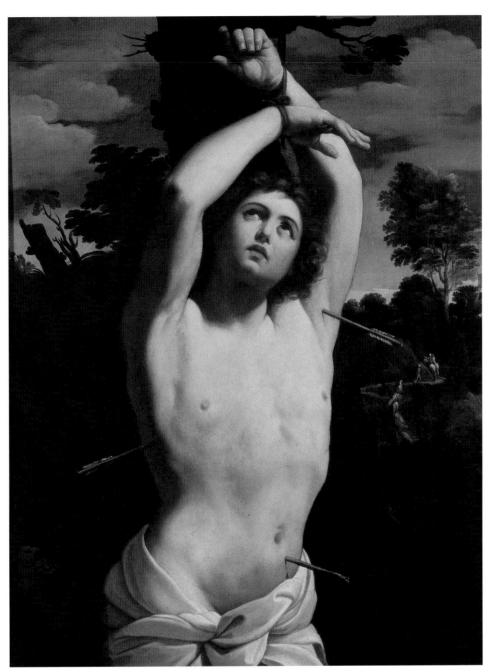

12.

place in 1628 after the cardinal's death. A *Saint Sebastian* by Guido Reni was also included. Together with the latter, there are at least two other famous paintings that came to the Capitoline collections from the Pio di Savoia collection: *St. John* and *The Fortune Teller,* both by Caravaggio. As suggested by Maria Elisa Tittoni, evidently the del Monte lot, composed of original paintings, was purchased by the Pio family.

In 1984, S.D. Pepper listed the Capitoline painting among the copies of the Genoese picture, but in 1988, after taking into account the documentary evidence, he included it among the autograph works and dated it to around 1615-1616. Finally Spear (1997) reiterated his previous opinion (1984) maintaining that the picture in Genoa could be a good replica of the Capitoline original.

PM

Bibl.: Baccheschi 1971, p.95 nr. 64b; Tittoni 1977, pp. 64-69; Pepper 1984, p. 232, nr. 48; Pepper 1988, p. 331 nr.18; Spear 1989, p. 371; Spear 1997, pp. 69, 341.

Giovanni Girolamo Savoldo

Brescia 1480/1485- Venice, post 1548

As a youth Savoldo studied in different
Italian cities. In Venice, which he visited
several times, he had the chance to know
the works of Giorgione and Titian, but his
main influence was the paintings of Lorenzo
Lotto. He received his most important
commissions from Venetian nobles and
the bourgeois families of his native town,
but he also produced many altarpieces for
churches. In his style, Venetian influences
merge with a distinctive use of light and a
marked realism that makes him an impor-
tant precedent for Caravaggio.

13.
Portrait of a Woman, c. 1525
oil on canvas, 92 x 123 cm (36-1/4 x 48-3/8 in.)
Capitoline inv. 49
provenance: Pio di Savoia

This unidentified woman is seated before a window through
which is seen a deep landscape. She wears a sumptuous
dress—her sleeves adorned with fur cuffs and her bodice
embroidered with daisies—and she holds a small prayer
book in her left hand. A little dragon, on the left, is tethered
to her belt by a chain.

The painting comes from the Pio collection, in whose
inventories it is variously referred to as in the manner of
Giorgione, and as by Dosso Dossi. At the end of the
nineteenth century it was recognized as a work by Savoldo.
The date is more difficult to establish, but is thought by
scholars (Ballarin 1990; Frangi 1993) to be in the mid
1520s, a period when the painter seems to have been
strongly influenced by the style of Lorenzo Lotto, who was
then working in the nearby city of Bergamo. The careful
realism and meticulous description of detail in the picture
are reminiscent of Lotto. Particularly effective is the
contrast of light between the inner space, where the woman
is placed, and the landscape on the right.

Scholars have sought the identity of this woman, whose
refined elegance and devotion is so exalted. In the past it
was thought, without any evidence, that she might be
identified with Eleonora, Duchess of Urbino. The presence
of the dragon suggests that the sitter might be portrayed as
St. Margaret of Antioch, who according to legend, had been
devoured by Satan (in the form of a dragon), but had
managed to survive. For this reason she became the patron-
ess of women in labor and the object of widespread popular
veneration. This identification is reinforced by the daisies
(*margheritina* in Italian) on her bodice. The sitter in the
portrait may be a woman whose Christian name was
Margaret. Gilbert has suggested that she was a member
of the Pio family.

SG

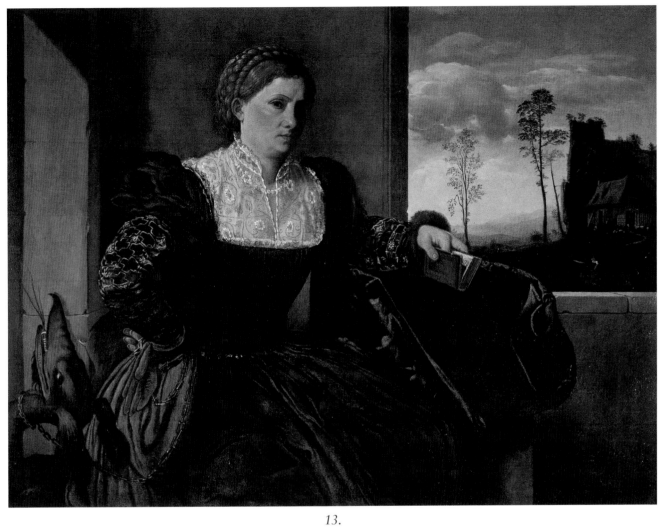

13.

Bibl.: P. V. Begni Redona in exh. cat. Brescia 1990, p.182, nr. I 33 (with previous bibl.); F. Frangi in exh. cat. Paris 1993, p. 401; Gilbert, 1994, pp. 120-124.

Scarsellino

(Ippolito Scarsella)
Ferrara c. 1550-1620

Scarsellino was educated by his father, an architect and a mediocre painter, in the mannerist milieu of Ferrara and Parma. His first works show the intense colors of Venetian paintings, a trait that intensified in the 1570s, during his stint in Veronese's workshop in Venice. Around 1590, repeated contact with the paintings of the Carracci lead him to a rejuvenated naturalism and religious tone that was in keeping with Counter-Reformation painting.

14.

The Adoration of the Magi, c. 1600
oil on canvas, 124 x 112.5 cm (48-3/4 x 44-1/4 in.)
provenance: Pio di Savoia

In this picture Scarsellino varies the traditional presentation of the subject: the Holy Family is shown before an architectural backdrop, rather than inside a manger. At the center of the work, the three Magi with their attendants present gifts to the Infant Jesus; above, music-making angels and the star that led the Magi can be seen.

The painting was recorded in the inventories of the Pio collection starting in 1697, although it is possible that the family had bought it several years before. The Capitoline Picture Gallery also possesses another, smaller version (from the Sacchetti collection) and its provenance was sometimes confused with the provenance of this picture (and vice-versa).

Scarsellino is the last great protagonist of Ferrarese painting. In his works—whose dimensions are usually small and are meant for private collectors— the artist was able to alternate influences and borrowings from mid-sixteenth century Venetian paintings, and his more recent experience of Bolognese painting, in particular the work of Annibale and Ludovico Carracci. The *Adoration of the Magi* belongs to a group of works Scarsellino carried out around 1600, a period when the artist composed his picture with "successive and sloping planes . . . the brush stroke is sure, the color is thick and rich" (Bentini 1992). Compared to his earlier style, with its traces of late Mannerism, these works signal a change, which perhaps was stimulated by Scarsellino's activity for local churches and convents: making copies of the Renaissance paintings that had been removed to Rome following Ferrara's conquest by the Papal States in 1598.

SG

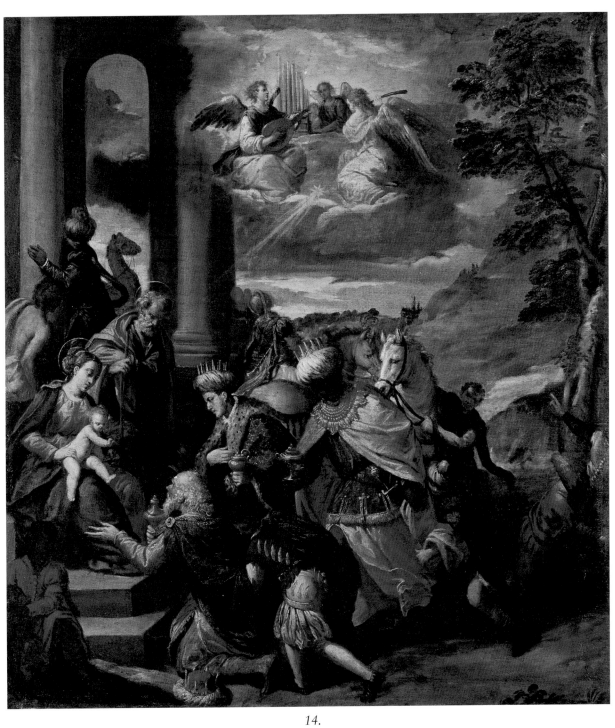

14.

Bibl.: Novelli 1964, p. 40; Bentini 1992, p. 264.

Pierre Subleyras

Saint Gilles 1699 - Rome 1749

After studying with his father, Mathieu, Subleyras joined the workshop of the painter A. Rivalz in Toulouse. In 1726, he went to Paris, and the next year won the Academy's *Prix de Rome*. This allowed him to study at the French Academy in Rome, and he remained in that city for the rest of his life, becoming a painter much appreciated by many collectors, including Cardinal Silvio Valenti Gonzaga. His most important works, mainly historical paintings and monumental altarpieces, reveal influences of Italian early Baroque painting, in particular, the Bolognese school. He was also one of Rome's most fashionable portrait painters, a rival to Batoni.

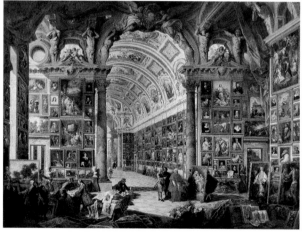

Giovanni Paolo Panini
The Picture Gallery of Cardinal Silvio Valenti Gonzaga, 1749
Oil on canvas
Wadsworth Atheneum
The Ella Gallup Sumner and Mary Catlin Sumner Collection Fund

15.

Portrait of Cardinal Silvio Valenti Gonzaga, mid 1740s
oil on canvas, 128 x 98 cm (50-3/8 x 38-5/8 in.)
Capitoline inv. 402
provenance: acquired 1995 from Count A.C. Ciechanowiecki

Cardinal Silvio Valenti Gonzaga (1690-1756) came from Mantua. As a youth he moved to Rome and had a brilliant diplomatic career in several European capitals. Benedict XIV appointed him Secretary of State, a position he kept until his death. The cardinal was also a passionate collector and a protector of arts: he founded the Capitoline Picture Gallery, opening the first public collection of pictures. His own collection included about 800 paintings and a conspicuous selection of valuable furniture, as we can see in the masterpiece painting by Giovanni Paolo Panini (a work in the collection of the Wadsworth Atheneum). In the Atheneum's picture, Valenti Gonzaga is portrayed in the midst of his collection, dressed in his rich, red cardinal robes, and holding his *biretta* (hat) in his left hand. In the Capitoline's portrait, he is isolated; behind him are a small tabernacle, a book, and an ink pot—clear reminders of the themes of religion, work and culture.

About the end of the 1730s and the early-1740s, Subleyras found Cardinal Valenti Gonzaga to be an attentive patron. The cardinal owned several works by the French artist— such as this portrait, probably carried out immediately after Valenti Gonzaga's appointment as Secretary of State—and they were exhibited in his residence (today the building is the seat of the French embassy to the Vatican).

In this painting, Subleyras hints discreetly at the moral virtues of the cardinal. He unflinchingly presents the portly features of Valenti Gonzaga, yet is able to convey the man's vivid intelligence and generosity. The cardinal's dress is masterfully rendered with bright contrasts of reds and whites, and hints of preciousness materials. This painting is, without doubt, one of the best examples of eighteenth-century portraiture, and, at the same time, it is a lively testimony to the deeply-felt friendship between Subleyras and his patron.

SG

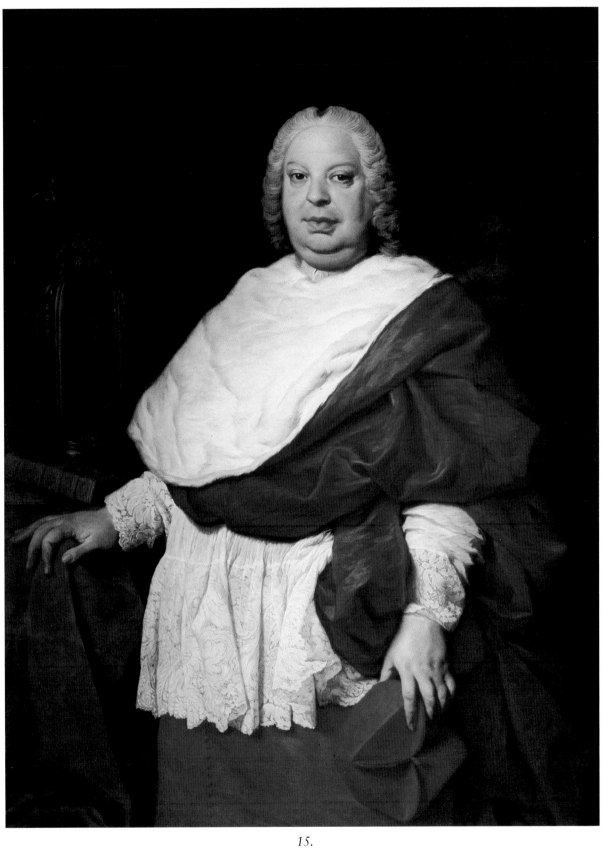

15.

Bibl.: Exh. cat. Paris – Rome 1987, pp. 94, 125; exh. cat. Rome 1996, pp. 26, 30 (with previous bibl.).

Gaspar Van Wittel

(called Gaspare Vanvitelli)
Amersfoort 1653 - Rome 1736

Van Wittel, also called Vanvitelli, settled in Rome as early as 1675. He was one of the first painters to popularize in Italy the Northern European topographical conception of landscape. His many views of Rome and other Italian cities (including Venice) are precious testimonies of the setting and the life of the period and represent an important precedent for Venetian view painting in the eighteenth century. Van Wittel's style is characterized by uncommon attention to detail and neat brushwork.

16.
View of the Temple of Vesta, c. 1680
oil on canvas, 27 x 61 cm (10-1/2 x 24 in.)
Capitoline inv. 166
provenance: Sacchetti

17.
View of the "Broken Bridge," c. 1680
oil on canvas, 27 x 61 cm (10-1/2 x 24 in.)
Capitoline inv. 167
provenance: Sacchetti

In January 1675, as soon as he reached Rome, Van Wittel made drawings of a trip he took following the Tiber river upstream with an engineer named Cornelis Mayer. Before long, perhaps before 1680, he started his activity as a view painter. Among others, he worked for the Sacchetti, who probably provided lodging for him. In the Sacchetti collection is a series of temperas on parchment, very delicately painted, that records views and prospects of Rome which no longer exist. The general locations are nonetheless easily recognizable because of the presence of many important monuments of different epochs that still exist today and compose the layers of history unique to Rome.

These two small views, carried out just after 1680, are a perfect example of the unique topography of Rome. In these works, the artist reproduces views of two areas of the city, Palatine and Aventine, which are very close to each other, located between the Tiber and the hills of the Capitol. The view of the so-called Temple of Vesta (in reality, the temple was dedicated to Hercules) shows the temple before the reorganization of the square, which was completed in 1717 with the placement of a fountain that is still there today. The view of what then was an uninhabited and unhealthy area also shows the medieval transformation of the old circular temple into a church (a frequent fate of pagan monuments in the Christian era) called Santa Maria del Sole: the colonnade has been filled in by a wail and a later chapel has been appended to the circular perimeter. We do not know any replica or preparatory drawing for the *View of the Temple of Vesta.*

The other painting depicts the Broken Bridge standing at a short distance from the Temple of Vesta, and downstream from the Tiberine Island, which is linked to banks of the Tiber by two ancient bridges built in the first century B.C. The Broken Bridge is the ruin of a bridge that was rebuilt in the sixteenth century on the foundation of the second

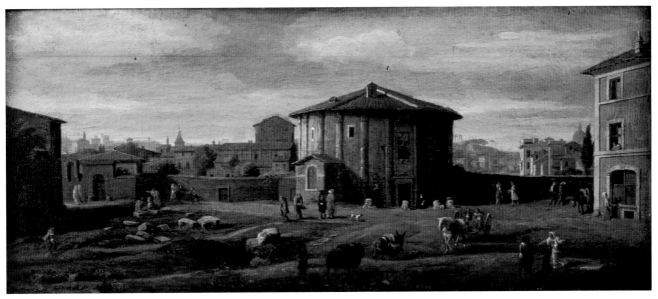

16.

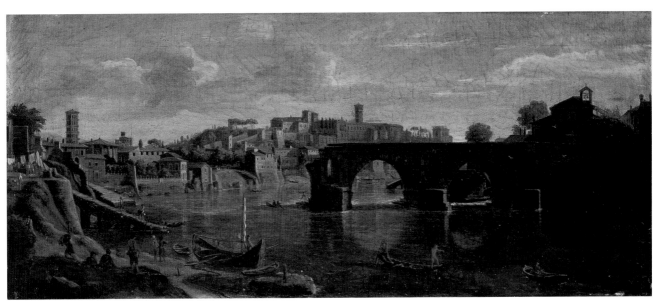

17.

century B.C. Emilio Bridge. In the foreground are the banks of the Tiber, a scene of much activity since in that period the river had great commercial importance. There are several versions of this subject: the oldest is in the National Gallery of Rome and is dated 1681; a pen and watercolor preparatory drawing is in the National Library of Rome.

The horizontal format, with the width almost double the height, is characteristic of the mature views by Van Wittel. His works present a descriptive and documentary rendering of the city and of everyday life as seen through Northern European eyes. His approach is unlike the ideal landscape and archeological views (painted by many foreign artists in Rome) that dominated Italian landscape painting of the seventeenth century.

PM

Bibl.: (Vesta) Briganti 1966, p. 184, nr. 44; P. Masini in exh. cat. Rome 1997, p. 77, nr. 21; (Broken Bridge) Briganti 1966, p. 208, nr. 104.

Diego Rodriguez de Silva y Velázquez

Seville 1599 - Madrid 1660

Velázquez studied with F. Herrera the Elder and then with Francisco Pacheco. Later, he moved to Madrid and in 1623 be became Court Painter to King Phillip IV. From 1629 to 1631 he visited Genoa, Venice, Rome, and Naples. During this first Italian journey he developed an extraordinary palette that distinguishes his works. In 1649-1651 be went for a second time to Italy to buy paintings for the king's collection. His extended stay in Venice and Rome produced the famous portrait of Pope Innocent X that now is in the Doria-Pamphilj Gallery in Rome. Upon his return to Madrid, he carried out his most famous masterpiece, *The Maids-in-Waiting*, also called *Las Meninas*, now in the Prado in Madrid.

18.

Self-Portrait (?)

oil on canvas, 67 x 50 cm (26-3/8 x 19-3/4 in.)

Capitoline inv. 62

provenance: Pio di Savoia

This portrait is listed in the inventory of the Pio di Savoia sale in 1750 as by Velázquez, but not as a self-portrait. It was considered by scholars of the last century to be the famous self-portrait (or its sketch) executed in Rome during Velázquez's first Italian stay. That portrait had been given as a present to his teacher, Francisco Pacheco, who recalled that it had been painted "a la manera del gran Ticiano" (in the manner of the great Titian).

Since the nineteenth century, questions about the attribution and the sitter's identity have become complex and intricate: it was even considered at one time to be a portrait of Bernini, or by Bernini. In the Madrid exhibition of Velázquez's works commemorating the third centenary of his death (1960), the painting was exhibited among the undocumented autograph works by Velázquez, but only questionably as a self-portrait. In his 1963 monograph (and also in the 1996 edition), J. Lòpez-Rey removed the work from the master's oeuvre, as have other scholars. In the recent exhibition (1990) in New York and Madrid, the painting was cited only as a comparison to the *Self-Portrait* of the Valencia Museum, without addressing the problem of attribution. Maurizio Marini (1990) believes that the Valencia *Self-Portrait* is the one that belonged to Francisco Pacheco, and that the Rome *Self-Portrait* is very likely the painting that was listed among the artist's belongings at his death as "un ritratto di Diego Velazquez incompiuto nelle vesti" (a portrait of Diego Velázquez unfinished in the clothing), which other scholars had considered lost. Marini also reminds us that, during his second Roman stay, Velázquez, protected by the pro-Spanish pope, Innocent X, had become a member of the Accademia di San Luca and also had joined the Virtuosi del Pantheon. In Marini's opinion, the Capitoline painting shows Velázquez dressed as one of the Virtuosi del Pantheon, with a white collar and black cloak. The problem is further complicated because there are no reliable self-portraits of Velázquez, with the exception of the one appearing in the famous painting *Las Meninas* (Madrid, Prado), where the artist portrays himself in the act of painting.

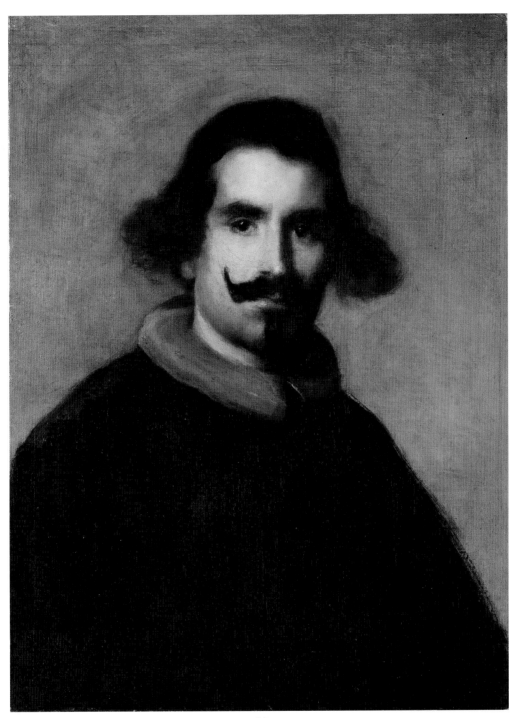

18.

A recent (1999) restoration has revealed severe damage from previous restorations, but also has made visible the high quality of the work. The robe is moreover seen to be unfinished, merely sketched. The painter focuses on the face, with its piercing gaze. It is difficult to believe that an anonymous painter or a copyist could have conveyed such expressive depth.

PM

Bibl.: Exh. cat. Madrid 1960, p. 84 nr. 87 (with previous bibl.); Pantorba 1960, p. 386; Péman 1960, pp. 700-701; Lòpez-Rey 1963, p. 288; Bardi 1981, p. 111 nr. 146; Harris 1982, pp. 78-79; J. Gallego in exh. cat. New York - Madrid 1989-90, p. 392, nr. 67; Marini 1990, pp. 115, 128; Lòpez-Rey 1996, p. 234.

Veronese

(Paolo Caliari)

Verona 1528 - Venice 1588

Born in Verona, Veronese worked on the Venetian mainland before moving to Venice in 1553. In the city, he took part in important public commissions. In addition, in Padua, Verona, and Vicenza, he decorated villas that had been designed by architects such as Sanmicheli and Palladio. His production includes portraits, altarpieces, and mythological paintings, many in magnificent settings. His painting is distinguished by the rich and luminous color range, a reference point for eighteenth-century painting.

19.
Allegory of Good Government, c. 1551
oil on canvas, cm 105 x 64 cm (41-3/8 x 25-1/4 in.)
Capitoline inv. 48
provenance: Pio di Savoia

20.
Allegory of Peace, c. 1551
oil on canvas, cm 105 x 64 cm (41-3/8 x 25-1/4 in.)
Capitoline inv. 50
provenance: Pio di Savoia

In 1818, the great altarpiece by Guercino of the *Burial of St. Petronilla* was exhibited in the Capitoline Picture Gallery, displacing many paintings. These were removed from the Capitol to the Vatican, where a new picture gallery was being organized. At that time a group of three paintings by Veronese, itself the remains of a larger decorative complex, was dispersed. An octagonal painting with the *Allegory of Liberal Arts (Poetry, Architecture, Painting)*, which was certainly the central element of the ensemble, is today at the Vatican Picture Gallery, while the *Peace* and the *Good Government* remain in the Capitol. The 1988 exhibition of Veronese's works at the National Gallery of Washington reunited the three paintings. We do not know the original location of Veronese's *Allegories* but, because they were meant to be seen from below, they very likely are fragments of a ceiling decoration, in keeping with Venetian decorative tradition.

According to S. Marinelli and L. Puppi, the paintings originally decorated the barrel vaulted ceiling in the Vicentine palace of the da Porto family, for whom Veronese worked between 1549 and 1552. This hypothesis is unconvincing for technical reasons, and because we know that the decorations of the da Porto palace were dismantled in the eighteenth century. Documents show instead that these three paintings were in Rome, in the Pio di Savoia collection, by 1697, when they were shown in the church of San Salvatore in Lauro at the annual exhibition of pictures loaned from prominent Roman collections.

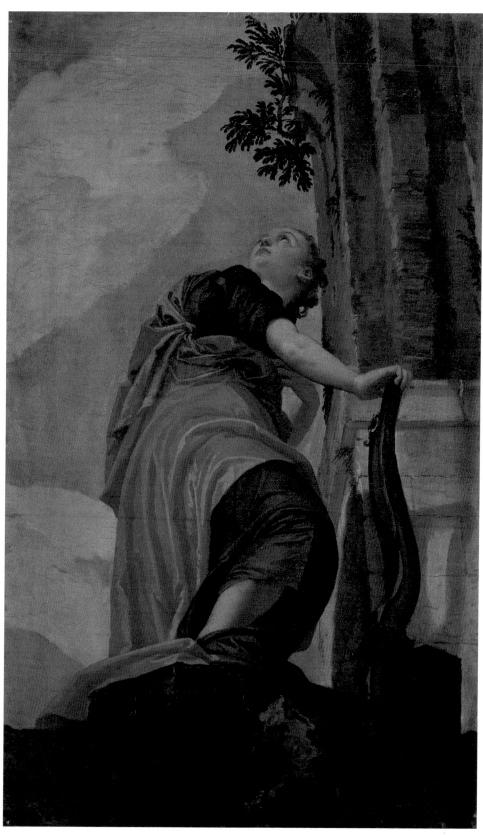

19.

The original arrangement can be easily reconstructed: with the *Allegory of the Liberal Arts* in the center, *Peace* burning the weapons should be set on the left, and the personification of the *Art of Statecraft*, with her head turned and her eyes looking upwards while holding the helm, on the bottom right. Even without the other parts of the set, the decorative program clearly exalts the civic virtues of the palace's owner: the triumph of the liberal arts is made possible thanks to the peace and good government granted by the patron.

In the past, most critics have dated the works around 1555, on the grounds of stylistic analogies with the painting of the ceilings of San Sebastiano in Venice. More recently, however, the date has been advanced to around 1551, suggested by the experimentation with colors visible in some passages.

PM

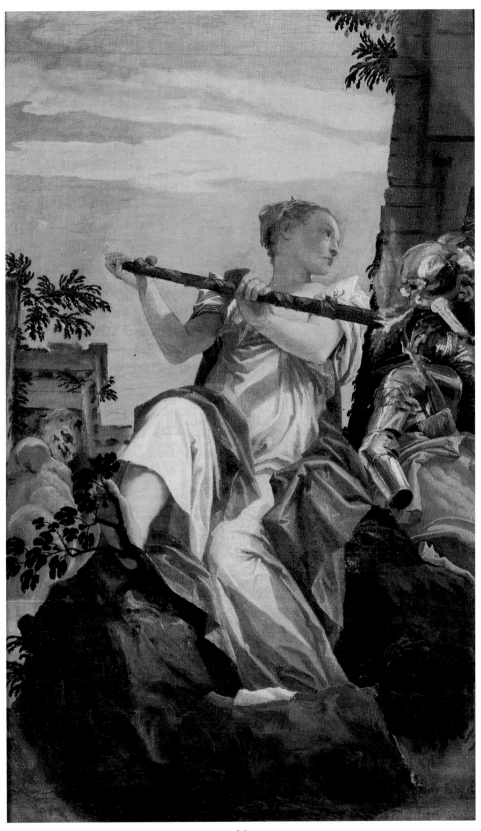

20.

Bibl.: W. Rearick in exh. cat. Washington 1988, pp. 41-43 (with previous bibl.);
Pignatti – Pedrocco 1991, p. 47; Masini 1994, p. 110.

Simon Vouet

Paris 1590-1649

Vouet lived in Italy between 1612 and 1627 and witnessed the birth of Baroque art. He was inspired by Caravaggio and the Bolognese painters (mainly Reni and Guercino), as well as by Venetian painting. In Rome, he worked in the Aleoni chapel in San Lorenzo in Lucina (1624) and in Saint Peter's basilica (1625-1626). Returning to France, he opened a workshop and adopted the pastel colors and decorative surfaces in vogue at King Louis XIII's court.

21.
Allegory (Intellect, Memory, Will), c. 1625
oil on canvas, 179 x 144 cm (70-1/2 x 56-3/4 in.)
Capitoline inv. 60
provenence: Sacchetti

Vouet reached Italy in early 1612 after a circuitous journey from Paris to London and Constantinople. He first stopped in Venice, where be studied the works of Titian, Tintoretto and Veronese. Arriving in Rome in 1614, he joined the large community of foreign artists who lived and worked in the Eternal City.

In 1625, Claude Mellan, a French artist who popularized Vouet's works, made an etching of this painting. Whether the *Allegory* had been painted shortly before (that is, around 1624, when Marcello Sacchetti's collection was formed; see below) or several years earlier, as suggested by Jacques Thuillier, is not known. An early dating would make this one of the artist's first Roman works

The etching by Mellan was dedicated to Marcello Sacchetti, banker and collector, who probably devised the subject and commissioned the work from the painter. In the same etching an inscription explains the rare subject of the painting as the faculties of the soul: the Intellect, with a flame on its brow; the Will, with wings and a crowned bead; and the Memory, with a double face (one facing the past, the other looking at the present and future). This imagery is drawn from the *Iconologia,* a famous book of the sixteenth century by Cesare Ripa, which was a frequent source for symbols.

A dramatic cascade of light illuminates the evening scene, highlighting the Will in the center, silhouetting Intellect and casting Memory into partial shadow. The scene is made imposing by the low viewing point and by the two broken columns, symbols of history which are inextricably inter-twined with the soul.

Even though the dramatic light is indebted to the works of Caravaggio, whose impact on Vouet as on other French painters in Rome was profound, the dominant influence in this painting is that of the Venetian and Bolognese painters (see, for example, the works by Veronese and Guercino in this catalogue). X-ray examination has discovered a version of the same subject underneath the *Saint Jerome and the Angel* in the National Gallery in Washington, carried out for the Barberini family.

PM

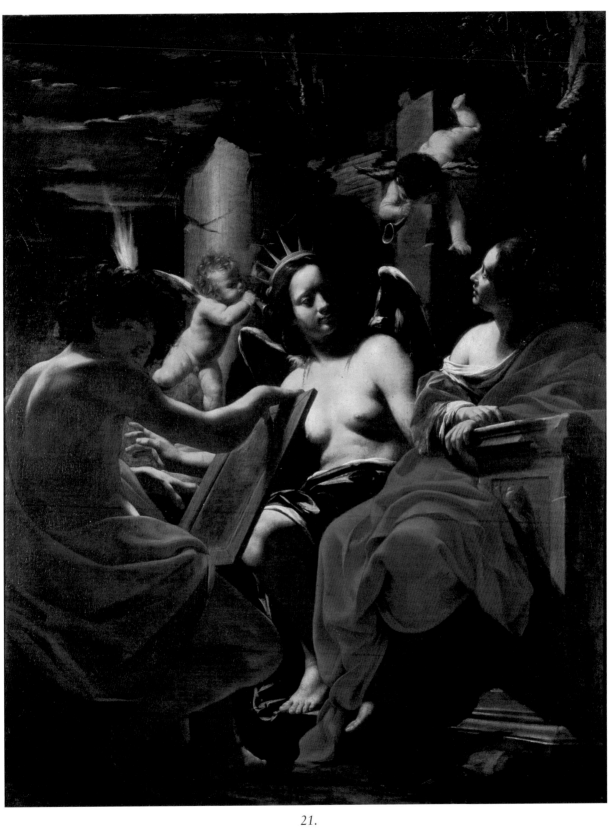

21.

Bibl.: J. Thuillier in exh. cat. Paris – Rome 1990-91, pp.189-191, nr. 5 (with previous bibl.); exh. cat. Lecce 1996, p. 262.

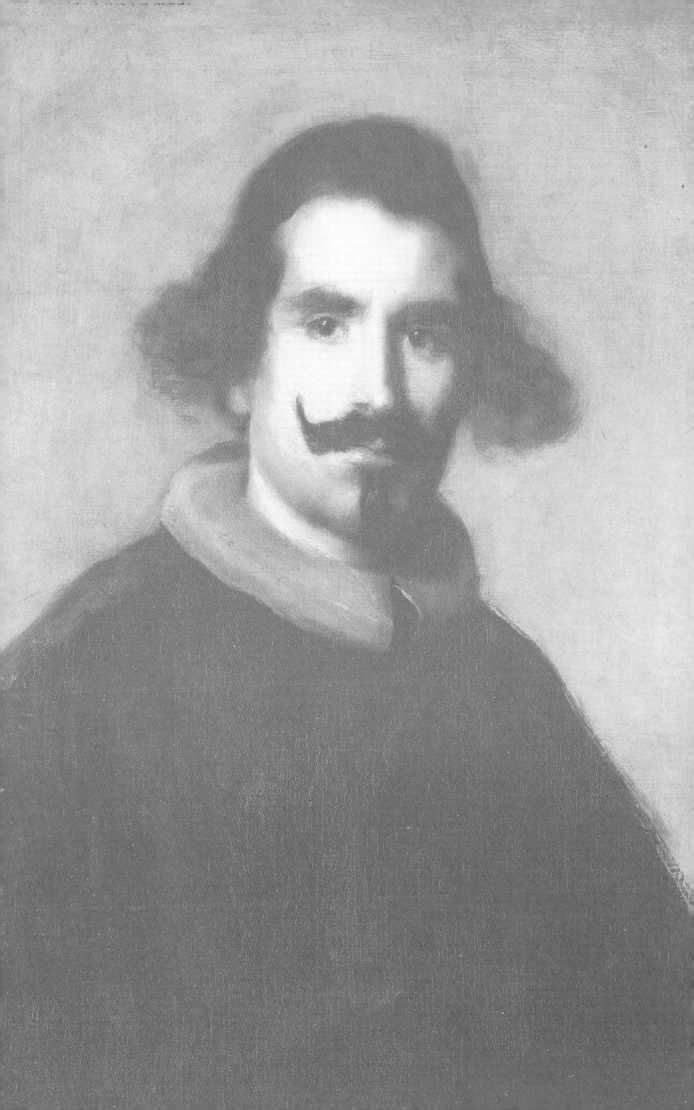

Chronological Bibliography

W. Arslan, "Opere romane di Pier Francesco Mola," *Bollettino d'arte,* VIII s.II, 1, 1928-1929, pp. 55-80.

D. Mahon, "Contrasts in Art-historical Method: Two Recent Approaches to Caravaggio," *The Burlington Magazine,* XCV, 1953, pp. 212-220.

A. Neppi, *Il Garofalo - Benvenuto Tisi,* Milan 1959.

B. de Pantorba, "Notas sobre cuadros de Velázquez perdidos," in *Varia Velázqueña,* Madrid 1960, pp. 382-399.

C. Péman, "Sobre, autorretratos de juventud de Velázquez," in *Varia Velázqueña,* Madrid 1960, pp. 696-704.

G. Briganti, *Pietro da Cortona,* Florence 1962.

J. López-Rey, *Velázquez: a catalogue raisonné of his oeuvre,* London 1963.

M. A. Novelli, *Lo Scarsellino,* Milan 1964.

A. Mezzetti, *Il Dosso e Battista ferraresi,* Ferrara 1965.

G. Briganti, *Gaspar Van Wittel,* Milan 1966.

F. Gibbons, *Dosso e Battista Dossi: Court Painters at Ferrara,* Princeton 1968.

E. Baccheschi, *Guido Reni: l'opera completa,* Milan 1971.

R. Cocke, *Pier Francesco Mola,* Oxford 1972.

M. Marini, *Io Michelangelo da Caravaggio,* Rome 1974.

A. Sutherland-Harris, "R.Cocke: Pier Francesco Mola," *The Art Bulletin,* I ,V, 1974 pp. 289-292.

T. Pignatti, *Veronese,* Venice 1976.

R. Bruno, *Pinacoteca Capitolina,* Bologna 1978.

M. E. Tittoni, "Il 'San Sebastiano' di Guido Reni nella Pinacoteca Capitolina," *Bollettino dei Musei Comunali di Roma,* XXIII, 1977, 1-4, pp. 64-69.

P.M. Bardi, *Velázquez. L'opera completa,* Milan 1981.

E. Harris, *Velázquez,* Oxford 1982.

R. E. Spear, *Domenichino,* New Haven – London 1982.

M. Cinotti, "Michelangelo Merisi detto il Caravaggio," in *I pittori bergamaschi - Il Seicento,* I, Bergamo 1983, pp. 205-641.

H. Hibbard, *Caravaggio,* London 1983.

S.D. Pepper, *Guido Reni,* Oxford 1984.

M. Calvesi, "Le realtà del Caravaggio - Seconda parte (I dipinti)," *Storia dell'arte,* 1985, 55, pp. 227-287.

G. De Marchi, "Mostre di quadri a S. Salvatore" in *Lauro* (1682 - 1725), Rome 1987.

M. Marini, *Caravaggio,* Rome 1987.

L. Salerno L., *I dipinti del Guercino,* Rome 1988.

S.D. Pepper, *Guido Reni. L'opera completa,* Novara 1988.

D. Stone, *Theory and Practice in Seicento Art: the Example of Guercino,* Ph.D. Dissertation, Harward University 1989.

R.E. Spear, "Re-viewing the 'Divine' Guido," *The Burlington Magazine,* CXXXI, 1989, 1034, pp. 367-372.

M. Marini, "Innocentius X Pont. Max. Olimpia Pont. Max.: Innocenzo X, Donna Olimpia Maidalchini Pamphili e Velázquez," in *Innocenzo X Pamphili. Arte e potere a Roma nell'età barocca, atti del convegno* (Rome 1990), Rome s.d., pp. 109-129.

A. Ghilardi, *Bartolomeo Passerotti*, Bologna 1990.

M.E. Tittoni, "Il 'San Giovanni Battista' nelle collezioni capitoline," in *AA.VV.*, *Identificazione di un Caravaggio*, Rome 1990, pp. 11-14.

R. Varoli - Piazza, "Il 'San Giovanni Battista': dalle fonti all'immagine," in *AA.VV.*, *Identificazione di un Caravaggio*, Rome 1990, pp. 33-45.

L. Puppi, "La committenza vicentina di Paolo Veronese," in *Nuovi studi su Paolo Veronese*, Venice 1990, pp. 340-346.

S. Guarino, "La Pinacoteca Capitolina dall'acquisto dei quadri Sacchetti e Pio di Savoia all'arrivo della Santa Petronilla del Guercino," in exh. cat. Rome 1991-1992, pp. 43-62.

J. Merz, *Pietro da Cortona*, Tübingen 1991.

T. Pignatti - F. Pedrocco, *Veronese. L'opera completa*, Florence 1991.

D. Stone, *Guercino. L'opera completa*, Florence 1991.

J. Bentini, "Il fascino della pittura veneta: il casto dello Scarsellino," in *La pittura in Emilia e in Romagna – Il Seicento*, Bologna 1992, II, pp. 218- 273.

A. M. Fioravanti Baraldi, *Il Garofalo*, Ferrara 1993.

S. Guarino, "L'inventario della Pinacoteca Capitolina del 1839," *Bollettino dei Musei Comunali di Roma*, n.s., VII, 1993, pp. 66-85.

F. Cappelletti - L. Testa, *Il trattenimento di virtuosi. Le collezioni secentesche di quadri nei palazzi Mattei di Roma*, Rome 1994.

Quadri rinomatissimi: il collezionismo dei Pio di Savoia, a cura di J. Bentini, Modena 1994.

L. Testa, "Un collezionista del Seicento: il cardinale Carlo Emanuele Pio," in *Quadri rinomatissimi* 1994, pp. 93-100.

S. Guarino, " 'Qualche quadro per nostro servizio' - I dipinti Pio di Savoia inventariati, venduti e dispersi," in *Quadri rinomatissimi* 1994, pp. 101-107.

C.E. Gilbert, "Savoldo, Cima, Parma and the Pio Family," in *Venezia Cinquecento*, IV, no. 8, July-Dec., 1994, pp. 120-124.

S. Guarino, "L'inventario Pio di Savoia del 1724," in *Quadri rinomatissimi* 1994, pp. 117-129.

P. Masini, "I quadri Pio di Savoia dal Campidoglio al Vaticano," in *Quadri rinomatissimi* 1994, pp. 109-115.

C. E. Gilbert, *Caravaggio and His Two Cardinals*, University Park 1995.

J. López-Rey, *Velázquez*, Cologne 1996.

J. Bonnet, *Lorenzo Lotto*, Paris 1996.

L. Barroero, "L' 'Isacco' di Caravaggio nella Pinacoteca Capitolina," *Bollettino dei Musei comunali di Roma*, n.s., XI, 1997, pp. 37-41.

R. Spear, *The "Divine" Guido. Religion, Sex, Money and Art in the World of Guido Reni*, New Haven - London 1997.

Exhibitions
(alphabetical by city)

Ancona 1981 = *Lorenzo Lotto nelle Marche. Il suo tempo, il suo influsso*.

Bologna 1968 = *Il Guercino. Dipinti*, ed. D. Mahon.

Bologna 1984 = *Bologna 1584 - Gli esordi dei Carracci e gli affreschi di Palazzo Fava*.

Brescia 1990 = *Giovanni Gerolamo Savoldo*.

Brussels 1963 = *Le Siècle de Bruegel*.

Ferrara - New York - Los Angeles 1998 - 1999 = *Dosso Dossi. Pittore di corte a Ferrara nel Rinascimento*, ed. A. Bayer.

Lecce 1996 = *Immagini degli Dei. Mitologia e collezionismo tra '500 e '600*, ed. C. Cieri Via.

London 1955 = *Artists in 17th-Century Rome*.

Lugano - Rome 1989-1990 = *Pier Francesco Mola 1612-1666*.

Madrid 1960 = *Velázquez y los Velazquenos*.

New York – Madrid 1989 - 1990 = *Velázquez*

Paris - Rome 1987 = *Subleyras 1699 – 1749*

Paris - Rome 1990-1991 = *Vouet*, ed. J. Thuillier.

Paris 1993 = *Le siècle de Titien – L'âge d'or de la peinture à Venise*.

Rome 1991-1992 = *Guercino e le collezioni capitoline*.

Rome 1995 = *Fiamminghi a Roma 1508-1608*.

Rome 1995 = *Caravaggio e la collezione Mattei*.

Rome 1996 = *Acquisti e doni nei Musei Comunali 1986-1996*.

Rome 1996 - 1997 = *Domenichino 1581-1641*.

Rome 1997 = *Il Tempo e la Memoria*.

Rome 1997 - 1998 = *Pietro da Cortona 1597-1669*, ed. A. Lo Bianco.

Washington 1988 = *The Art of Paolo Veronese 1528-1588*, ed. W.R. Rearick.